complete
feltmaking

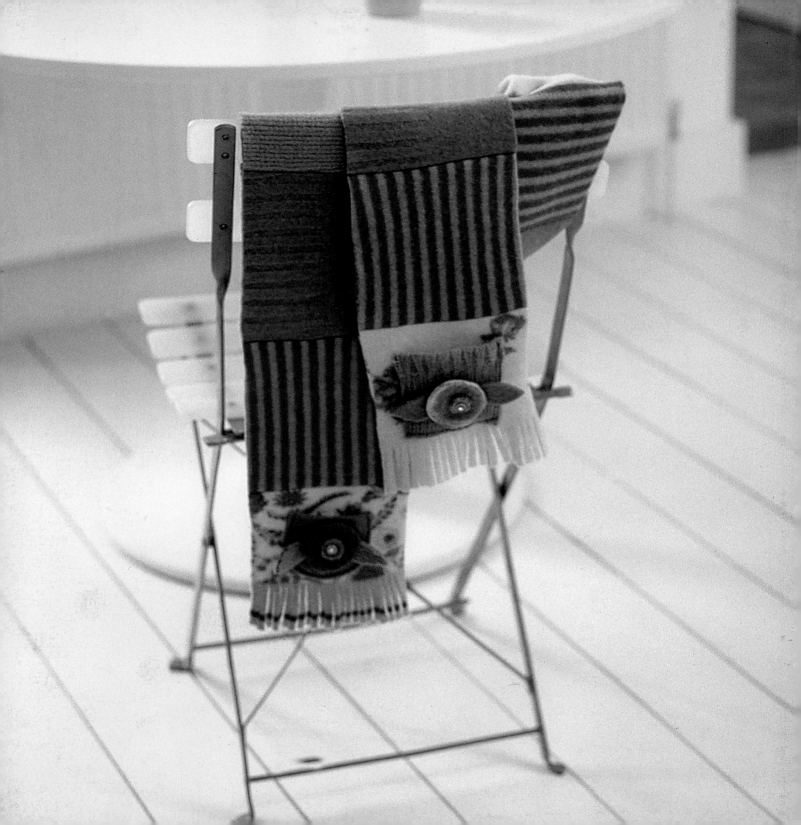

complete feltmaking

EASY TECHNIQUES AND 25 GREAT PROJECTS

GILLIAN HARRIS

COLLINS & BROWN

First published in the United Kingdom in 2006 by
Collins & Brown
151 Freston Road,
London
W10 6TH

An imprint of Anova Books Company Ltd

Commissioning Editor: Michelle Lo
Design Manager: Gemma Wilson
Designer: Roger Hammond
Photographer: Mark Winwood
Illustrator: Kang Chen
Copy Editor: Marie Clayton
Senior Production Controller: Morna McPherson

ISBN 1 84340 369 2

A CIP catalogue record for this book is available
from the British Library.

10 9 8 7 6 5 4 3 2 1

Reproduction by Anorax, UK
Printed and bound by WKT Co Limited, China

This book can be ordered direct from the
publisher. Contact the marketing department,
but try your bookshop first.

www.anovabooks.com

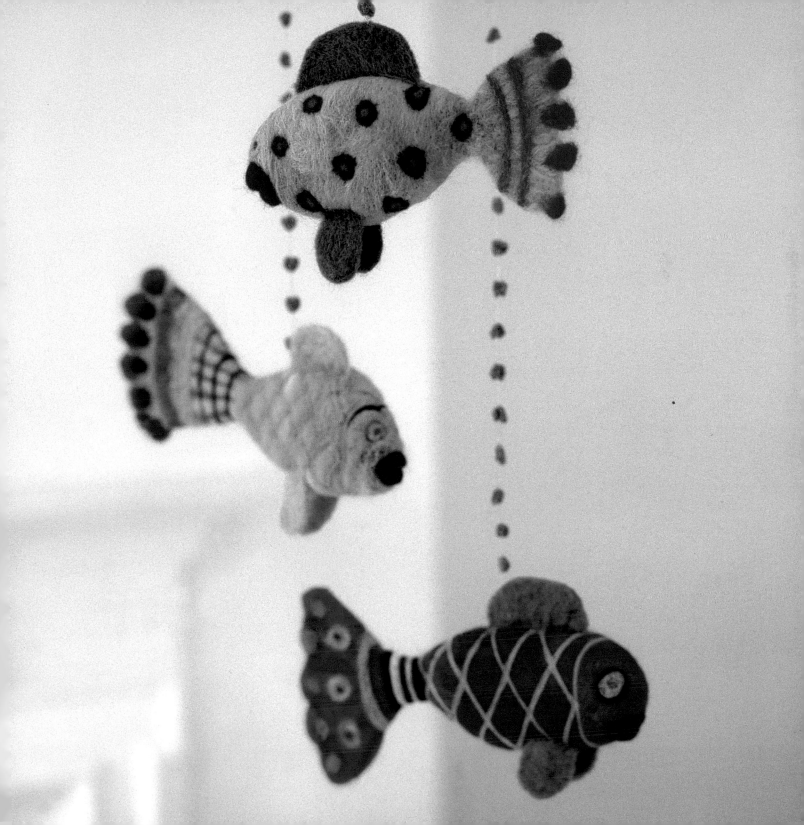

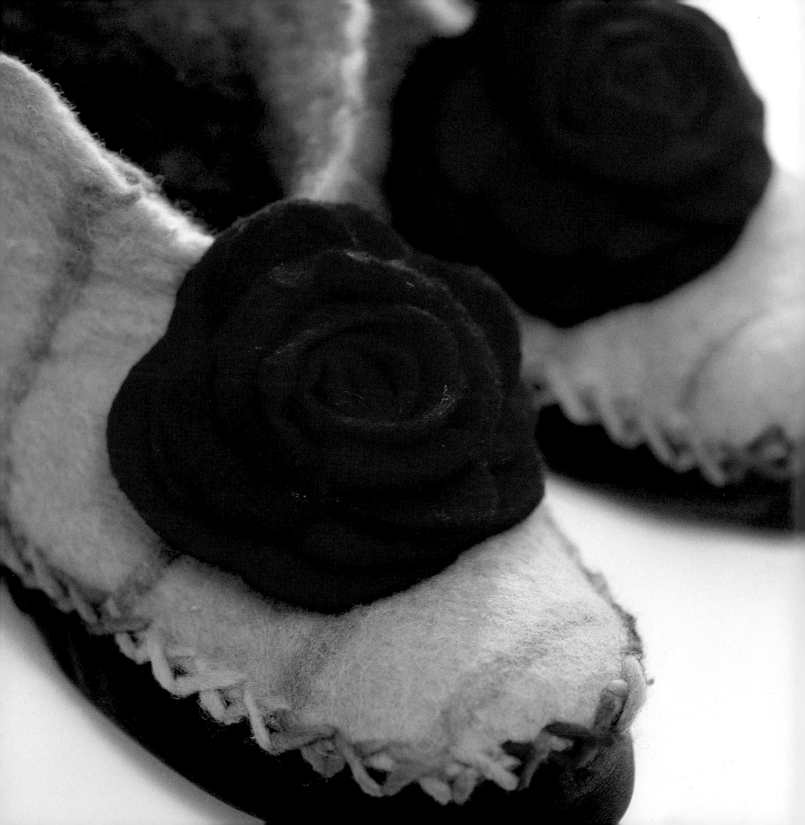

contents

introduction

I've been obsessed with making things from as far back as I can remember. At the age of six, I pieced together a small wobbly pincushion from felt and sent it along with my parents to a dinner party as a gift for the unsuspecting host's daughter – my best friend Joanna. Although this meagre offering was naively constructed from synthetic felt it was still soft to the touch, it was vibrantly coloured and appealing, and it didn't fray – an important discovery for any six-year-old.

The word 'felt' often conjures up images of mass-produced multicoloured squares, or perhaps the green stuff found under piano keys or on pool tables. However, as you are about to discover, 'real' handmade wool felt is quite a different material and bears little resemblance to the synthetic variety.

Handmade or hand-rolled felt is often made entirely from wool fleece that has been cleaned and combed (carded). The felting process starts when microscopic scales on each fibre of wool move and link together, by rubbing the fleece with soap and water. Once the fibres have clung together, the felt is then 'fulled' into a dense, hardened mat using heat and friction. The fulling process makes the felt shrink quite considerably.

Of course, most of you will be familiar with this irreversible process, which may have happened to a favourite wool sweater in the washing machine! A simulation of this washing machine cycle is re-created during the feltmaking process, but in a far more controlled manner. What we are left with at the end is a fire retardant, water repellent, warm and insulating, soft and cosy, breathable, protective, pliable, colourful, non-fraying

fabric – namely wool felt. With a multitude of applications, it's no wonder that so many of us love making it.

I had two goals in writing this book. The first of which was to encompass all aspects of feltmaking. While wet felting, needle felting, and knitted felting differ greatly when it comes to technique, they all start with the same element, wool, and they all end with the same result, felt. The different ways of making felt lend themselves brilliantly to different end results. This book starts with simple flat felting and sculptural felting in 3-d using templates, then covers soapless waterless needle felting, moves through felted knitting, and ends with more advanced projects such as felting onto fabric (nuno felt), cobweb felting and other interesting techniques.

My second aim was to inspire, motivate and unleash creativity in as many people as possible. So often, people come to my courses feeling sceptical or unsure about their artistic potential and creativity, and I really want to try and get across that 'letting go' and HAVING a go is what it's all about. No matter how inexperienced you are at crafts, and regardless of your level of creativity, it is difficult to go wrong. Felt is forgiving in the extreme for beginners, and yet receptive, transformable, diverse and full of endless possibilities for enthusiasts and experienced artists. Making felt is one of the few things in life that rewards its maker with a warm fuzzy feeling on the inside AND the outside!

Feltmaking is an art, not a science. My instructions, tips, and tricks in this book are what I have found works best for me, but if you discover different ways of doing things for yourself, use them! Nothing in this book is set in stone, but I have created a range of projects that I trust you will learn from and enjoy. I hope you will then be inspired to experiment a little too and take your feltmaking forward with your own ideas.

Jill

history of felt

Feltmaking is a very ancient business. Don't be fooled into thinking this is a recent discovery – far from it! Making felt from wool was around way before spinning or weaving with wool. Felt has been in existence for literally thousands and thousands of years and dates back to the early Neolithic cultures.

As wool fleece from sheep was placed around the feet and under saddles for protection, comfort, and warmth, the moisture from sweat coupled with the friction and heat from movement resulted in the first felts, and so feltmaking was born. Felted saddle blankets, masks, animal figures, socks, boots, hats, clothing, shields and carpets are in evidence all over the world, in places as far away as Persia, India and China.

Nomadic tribes in central Asia, Siberia, China, and Mongolia soon discovered the protective qualities of felt, and covered their movable tents ('gers' or 'yurts') with it for thousands of years – some continue to do so today. Groups would work together to design and make large pieces of felt to be used as shelter for the community as a cool retreat in hot weather and a practical insulated haven during winter months.

The worldwide felt phenomenon was also apparent in Ancient Greece, where the Greek soldiers allegedly used wool felt to line their helmets. Not to be outdone, Roman soldiers also used felt in breastplates. To provide insulation from the extreme cold, Scandinavians have also been using wool, felt and felting for thousands of years. Likewise in Turkey,

where they still make felt rugs today.

Since the Industrial Revolution, felt has been made by machines in large sheets of varying thickness, often from a mixture of synthetic fibres mixed with wool. There is a wet method, and also a dry method using thousands of barbed needles on a flat bed, which are pushed in and out of the fibres until they become meshed together and form sheets of fabric. These are the same sort of needles that are used for needle felting in this book.

Machine-made felt has many uses. Apart from machine-pressed felt hats (caps, trilbies, bowlers, cloches, and berets), mass-produced felt is used in many other applications for its sound deadening and insulating qualities. For example, felt is used in pianos to deaden the sound by preventing wood and metal banging together. It is also used as an insulating roofing material, a protective material in packaging, as the cover on a pool table, as an air filter or a washer – and so the list goes on.

If you would like to learn more about felt and feltmaking, various museums around the world showcase relics from ancient civilizations. Many fascinating artifacts dating back to the 5th century BC – preserved by the freezing conditions of the high Altai mountains where they were found – can be found at The State Hermitage Museum in St. Petersburg in Russia. In addition, there is also a Felt Museum in Mouzon, France, which covers the historic and contemporary aspects of feltmaking.

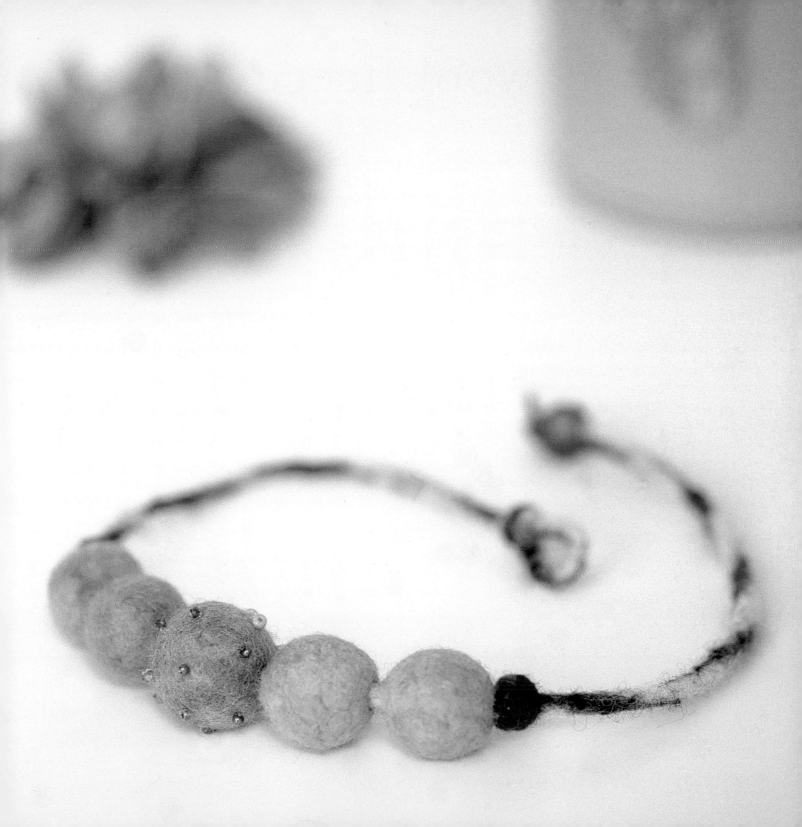

wool fleece

The wool normally used for feltmaking is often referred to as wool tops or roving, although in this book I sometimes just call it wool fleece. Wool top is wool that has been taken from the sheep, cleaned (scoured) and combed (carded) so all the fibres face the same way, then wound into a continuous length. Roving is similar, but the fibres do not necessarily all lie in the same direction.

Many different breeds of sheep provide us with many different wool tops suitable for felting. Of those readily available, Merino wool tops are the easiest and fastest to felt together because they are finer. Also Merino is available in the largest palette of colours – a constant source of inspiration to the feltmaker. Coarser, un-dyed wools do have their wonderful qualities too, offering different textures and often a robust felt when finished. Most wools will felt together eventually if you persevere, but finer wools with a slightly finer crimp, such as Merino, Blue Faced Leicester, Jacob, and Shetland, will felt that much more easily and quickly.

Wools are graded in several different – and often confusing – ways. The three most common are:

Micron – The most modern and simple measuring system, which measures the diameter of the wool fibre under a microscope using a measuring system based on a millionth of a metre (1/25,000 of an inch). Very precise!

Bradford count – A British measuring system dating from the 19th century, which represents fibre fineness and length by measuring the number of 560-yard skeins spun from one pound weight of clean wool. For example, you will sometimes see wool referred to as '64's', which means it has a Bradford Count of 64; there were 64 skeins of wool produced from one pound of the wool so the fibres are very fine. If it had a count of 48, only 48 skeins would have been produced and the fibres will be thicker and coarser.

Blood count – An older and rather imprecise American system referring to the amount of Merino breed in the sheep that the wool comes from. Since Merino was considered the finest and most suitable wool for felting, this grading system refers to it as 'Fine Wool'. A sheep that is a cross between Merino and another

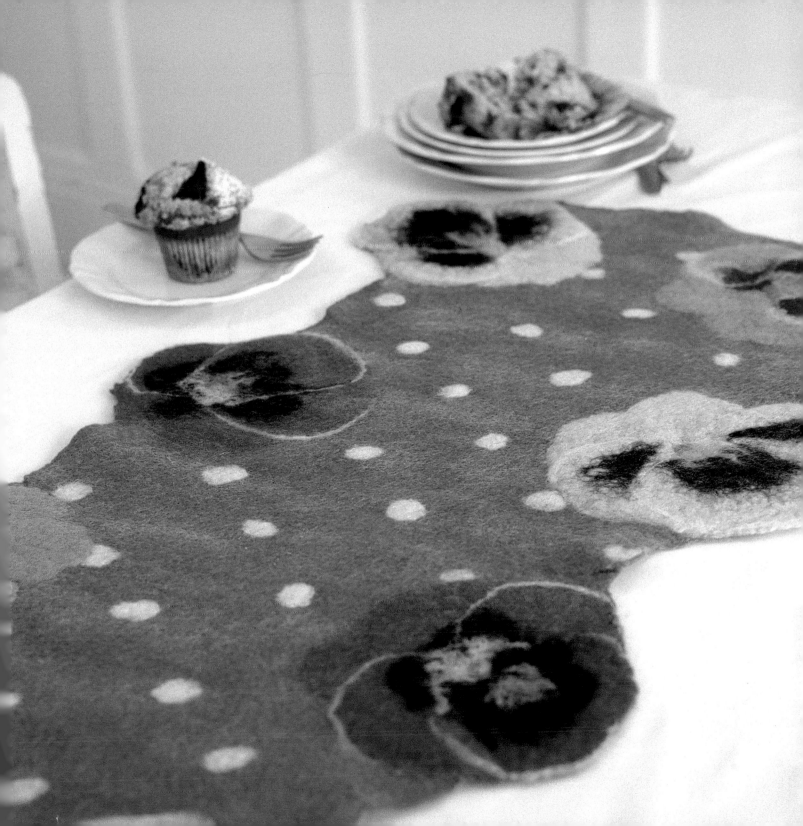

breed will produce wool that is slightly coarser with a slightly larger crimp. This wool would be referred to as '½ Blood Wool'. If the sheep is crossed again its wool would be '⅜ Blood Wool', and then '¼ Blood Wool' and so on.

As a general rule of thumb, the higher the wool count and the lower the micron, the finer the wool – the grading systems therefore determine each wool's 'feltability'. Wools such as Merino, Corriedale, Blue Faced Leicester, Finnsheep, Targhee and Jacob (to name but a few!) are all graded differently. They all felt well, but at different rates because of their different fibre length and thickness. As an example, the Merino I have used in this book is about 23 micron, and 64 count and is 'Fine Wool'. It has very fine crimp and a short staple length, and therefore felts very quickly. As a contrast, Finn wool would be referred to as '¼ Blood' and is 27-30 micron with a count of 50-54. It has a much longer staple length and a coarser or larger crimp. Therefore one can deduce that the Finn wool will take longer to felt than the Merino. This is worth remembering if you are combining different breeds and different grades of wool in the same project; it may take a lot longer to achieve the desired result because different wools will felt at different rates.

Once you have purchased your wool tops or roving for feltmaking, remember to store it away from moisture – too much moisture will make it coarse and harder to work with – but if possible let air circulate around it. Storing it in plastic bags for short periods of time does no harm, but do not leave it packed like this for very long periods. You should also take care to repel moths, which may decide to lunch on your stash!

Fleece wool tops get harder to pull apart the older they get, and if they are left out in the air for long periods of time they lose their springiness and feel harder and more matted. When this happens, they can still be used for feltmaking, but the fibres need to be teased apart more than normal before pulling the wispy end fibres off.

The key to making successful felt is to pull the wispy end fibres from the wool tops and then layer them up thinly and slowly. It is really important not to cut corners by working with wads of fibres that are too thick. As you practice and become more in tune with the process you will be able to judge how to use the wool fleece most effectively.

While working with wool fleece can be very rewarding, sometimes it can also seem time consuming – especially for the beginner. If you can't finish a project in one sitting, it's fine to leave it in an OPEN plastic bag and go back to it another day. Make sure you don't seal it in a bag as it will go mouldy and smell. You will more than likely have to re-wet it if you leave it for more than an hour, as the water will evaporate quite quickly.

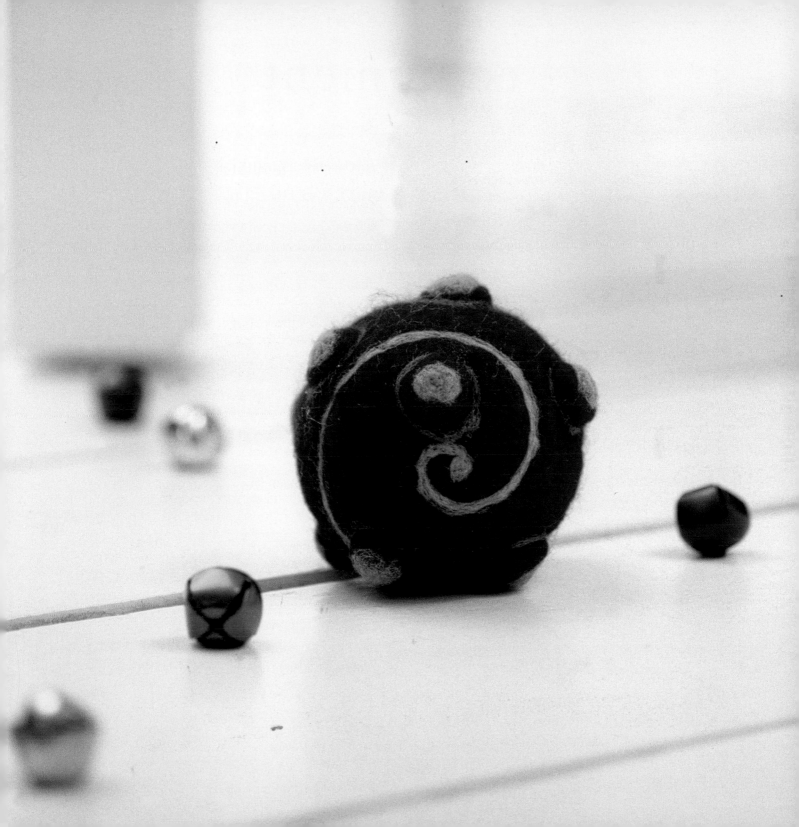

equipment

The workspace and equipment requirements for feltmaking are fairly simple and user-friendly. A reasonably large table or working area near to a sink is important. Hot and cold running water and access to a kettle are also a must.

I encourage feltmaking using minimal amounts of water, but bear in mind that the odd soapy splash should be expected and your working area should be protected as necessary. When needle felting no water or soap will be required, so just a small table space in any convenient position is all that is needed.

As well as the specific equipment listed here, you will need a selection of different sized scissors and basic sewing equipment, such as needle and thread and embroidery thread, for some of the projects.

Wet Felting

Net curtain/mosquito netting – A large piece of medium-weight polyester netting to lay over your fibres before you begin wetting them. This will enable you to start rubbing with minimal disturbance of your design.

Soapy water – A mixture of warm water with a dash of washing up liquid in some sort of bottle so you can dispense it slowly. A clean plastic ketchup bottle is useful when working with larger, thick layers of fibre and a spray bottle for small and delicate projects. You can also use a drinking bottle with a sports cap.

Dish cloth and bowl – A dish cloth is handy to mop up excess water and to spread retained water through the fibres, thus eliminating the risk of 'overwetting'. You will also need a bowl to squeeze the dish cloth out into, to save running to the sink every five minutes.

Soap – Many feltmakers prefer to use an olive oil or low lather soap, but any soap will do. The alkalinity of the soap is what is important here, since it speeds up the feltmaking process, and its slipperiness aids rubbing. An oily soap is kinder to hands, but the lanolin present in wool prevents hands from becoming too dry. When fulling items in the washing machine, use ordinary washing powder – make sure it does not have fabric softener in it and that it is not a special wool detergent, since this will prevent felting.

Kettle – A kettle nearby to produce a constant supply of boiling water when you need it is very handy. While you can substitute very hot tap water [over 60°C (140°F)], using water straight from the kettle that is very near boiling point will produce much faster and better results.

Rubber gloves – There is no need to wear rubber gloves when rubbing, but you will need them to protect your hands when you are pouring boiling water over your work.

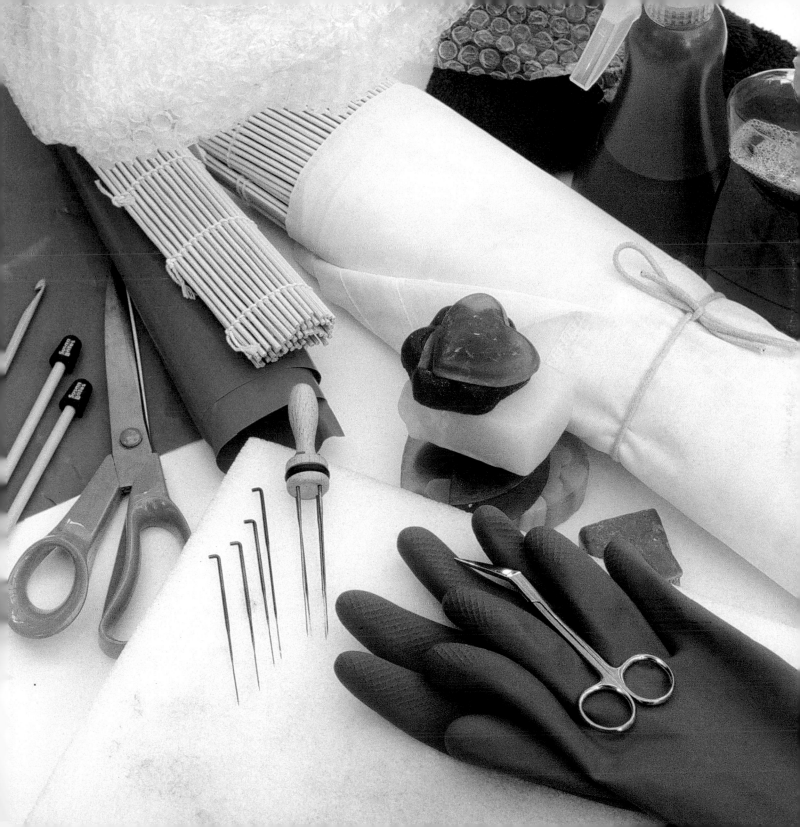

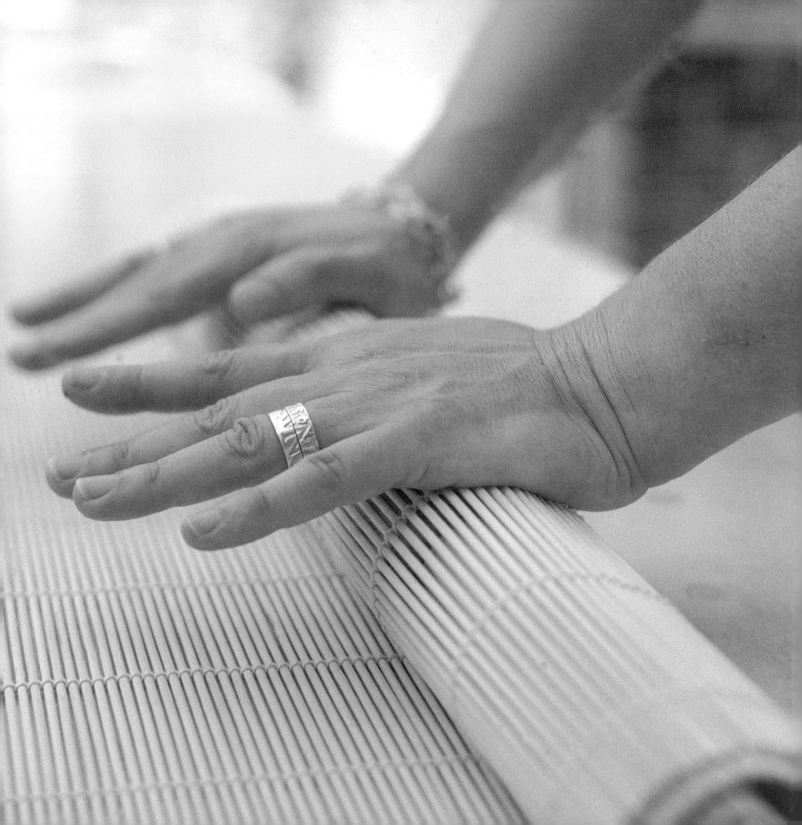

Bamboo blind or mat/bubble wrap – When making a flat piece of felt, it is wise to work directly on a bamboo blind or a piece of bubble wrap to provide as much friction as possible underneath the felt while you are rubbing. Also, once the first stage of the felting process is complete and the fulling stage begins, using a bamboo blind for rolling is the best option for fast and effective results – this is what I use throughout the book. Bubble wrap can be substituted if necessary, or as another alternative, some people prefer to use a washboard and simply rub the felt against it until it starts to shrink. A smaller bamboo sushi mat is invaluable for making smaller projects.

Towels – Great for placing under your bamboo mat before you start – both to soak up any excess water and to keep the bamboo mat in place during the rolling process. Also important for drying hands between rubbing wet fleece and touching the dry fleece.

Templates & blocks – The thick plastic that is available from DIY stores or builders' merchants is ideal for making templates. It retains its shape when hot, and you can feel the edge of it, even through several layers of fleece! You can also make templates from bubble wrap. A polystyrene hat block is great if you intend to do a lot of hat making, but for a one-off project, substitute a head-sized bowl! Polystyrene slipper forms are required for the slipper project in chapter 5, but if these are unobtainable, you can try using rubber wellington boots instead!

Washing machine – Most of the knitted projects require 'fulling' or felting in the machine. In case you don't have one available, I also outline alternatives, for hand felting.

Needle Felting

Dense foam – It is wise to keep a rectangle of dense foam to use under all your needle felting. This will protect your table, and will protect YOU if you are not working at a table!

Felting needles – A selection of different sized felting needles for different types of work (see glossary on page 156 for further details). These are extremely sharp, so use them with caution and take care. A multi-needle tool that holds several needles for use at the same time is useful for larger areas.

Foam shapes – When making larger pieces, either form a core shape using bunched fleece or cut out foam shapes to work around.

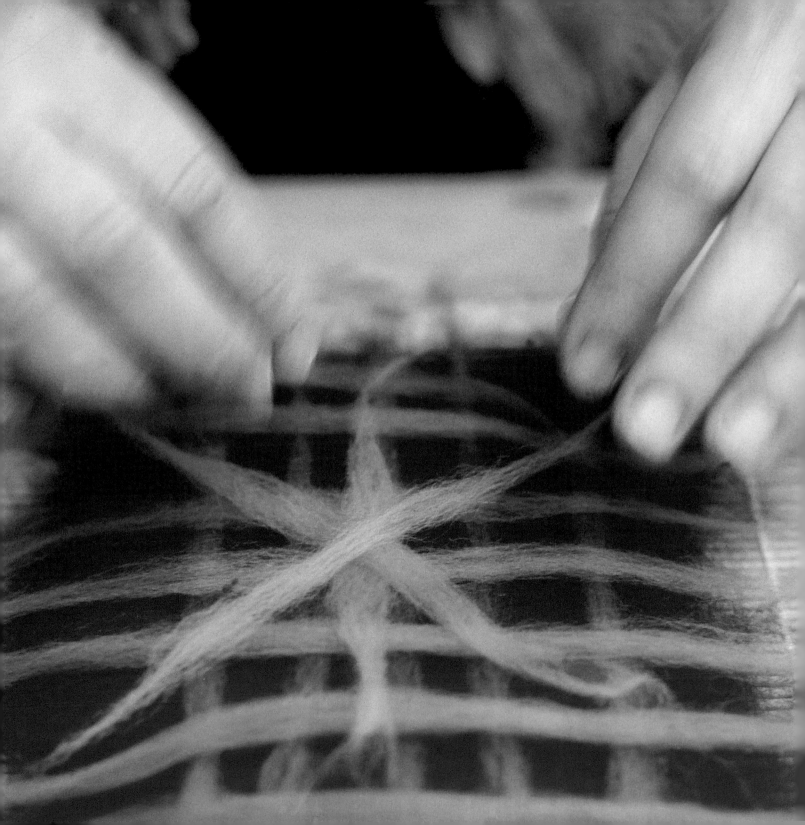

simple flat felt

This basic technique introduces you to the art of feltmaking and acts as a platform on which to build new felling skills. Learning how to handle the fleece and how to manipulate the fibres in order to shrink and harden the felt will shape you up for chapters to come! Experiment with different water temperatures and time of rubbing and rolling as you work to get a feel for the feltmaking process – while creating some fantastic projects at the same time!

The basic techniques will start you off on your feltmaking pursuits. The key thing here is to obtain wispy fibres that will be layered on top of each other – do not use great wads of fleece! The layers will always be applied in alternating directions, either horizontally or vertically. When wetting the felt, it should be thoroughly dampened, but not soaking wet. The harder you rub, the quicker the results.

1 Choosing fleece

Once you have selected your colour of wool tops, hold a long length of fleece in one hand about 10cm (4in) from the end and with the other hand, gently pull wispy pieces of fleece away with your finger tips and the fleshy base of your thumb. Keep your hands apart – holding the fleece with your hands too near to each other will prevent the fibres from coming loose and separating.

2 Laying out fleece

Lay fleece directly onto the bamboo mat, keeping all the fibres running in the same direction to form the first layer. By a 'layer', I mean laying down enough fleece to prevent you from seeing whatever is underneath – be that the table or mat or netting. You will need to build up two or three layers of fleece, depending on how hardy your finished piece needs to be. Continue with the next layer, by applying fleece in the opposite direction. This will help the fibres tangle together when you start to rub. Do not bunch the fleece up into a lumpy uneven wad – keep it as even and fine as you can and build the thickness up slowly.

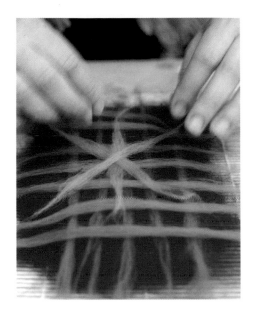
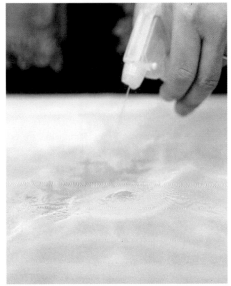
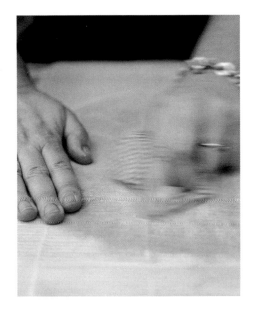

3 Designing with fleece

To make a motif, pull off a small length of fibre. Spread and separate it between your fingers, working with the fleece as loosely as you can. To make a circle, pull away a strand of fleece and coil it so the ends overlap. Work with similar colours on top of one another to add depth and interest. Remember that your work will shrink and that individual elements will be defined as this shrinkage occurs, so keep your designs as loose and open as possible.

4 Wetting

Lay the netting on top of your fleece, taking care not to disturb your carefully laid out designs. Using either a spray gun or another sort of water dispenser, sprinkle warm soapy water across the entire design area. Avoid over-wetting your work: you can always add more water little by little, but you shouldn't need to get the mop out!

5 Mopping up

Spread the water through the fibres and soak up any excess by wiping over the netting with a cloth, wringing out excess water into a bowl. There is a fine line between 'too wet' and 'not wet enough', so continue this process until your fleece feels like it is completely 'stuck' flat or matted. When it is pressed, there should be no puddles of water, but at the same time, there should also be no air pockets of springy fibres. Once the whole area is wet, you can peel back the netting to adjust the placement of any elements of the design that may have moved around during the wetting process.

Keep it Loose

Creating light, compact spots, spirals, lines, motifs or designs will make life difficult during the rubbing stage. The little fibres will not move around and tangle with those underneath, so they will only tangle and eventually felt with themselves. Keep your designs open and loose to save a great deal of time and effort!

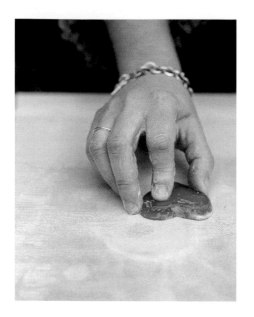

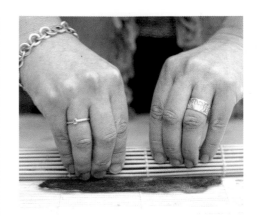

6 Swelling

Rubbing a bar of soap over the netting will help to make the next step of rubbing the fleece much easier. In addition, and more importantly, the alkalinity of the soap will encourage the felting process to start, by making the microscopic scales on the wool fibres start to swell and move open. In my experience, the soapier the better, although some feltmakers feel that too many air bubbles in the lather may impede the felting process.

7 Rubbing

Keep the netting as flat as you can while you rub. The agitation from the rubbing encourages the fibres to entangle, so use both hands and plenty of pressure – don't tickle it! Some fibres may come through the netting, but if you find an abundance, simply remove the excess by peeling back the netting while holding your fleece down underneath with the other hand at the same time. Continue rubbing for about ten minutes. You will know when you are done once you are able to slide your hand across the fleece design and the fibres no longer move. When your piece is well held together, rinse it in warm water until most of the soap is out. It may still be a little delicate, so don't leave it under a running tap! Squeeze out all excess water.

8 Rolling up your felt

This part of the felting process is the fulling part, which is when the felt really starts to harden and shrink. Roll the felt up in the bamboo mat as tightly as possible. Don't worry if it distorts a bit as you roll it up – it will all flatten out in the end.

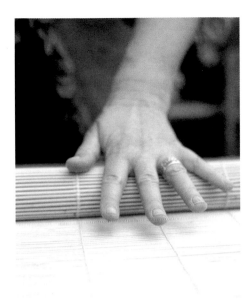

9 Rolling the mat

Because your felt will shrink in the direction in which it is rolled, it is important to roll it in all directions to prevent uneven shrinkage. Roll the mat back and forth with firm, even pressure about 20 times. Unroll, turn the piece 90º, and repeat. Continue until you have moved through a full 360º, then turn your felt over and repeat the rolling process. Rinse your project with very hot water. Leave it to cool slightly, then shock it under a freezing cold tap. Repeat the rinse process, making sure the felt is rinsed thoroughly and all soap is removed. While it is still warm, repeat the rolling process until the piece has shrunk to the desired size. Lay flat to dry in a warm place – an iron set on the wool setting can be used to speed up the drying process.

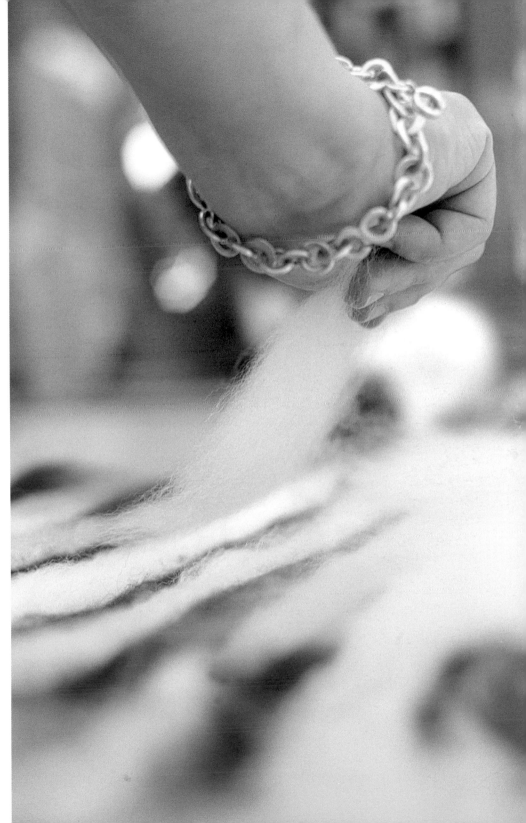

beginner

petal play

This simple and flowery hair tie is an ideal beginner project. Make two pieces of flat felt, cut them into flowers, and adorn with a scattering of colourful sequins and beads. The pretty project is so versatile, it can also be made into barrettes and brooches.

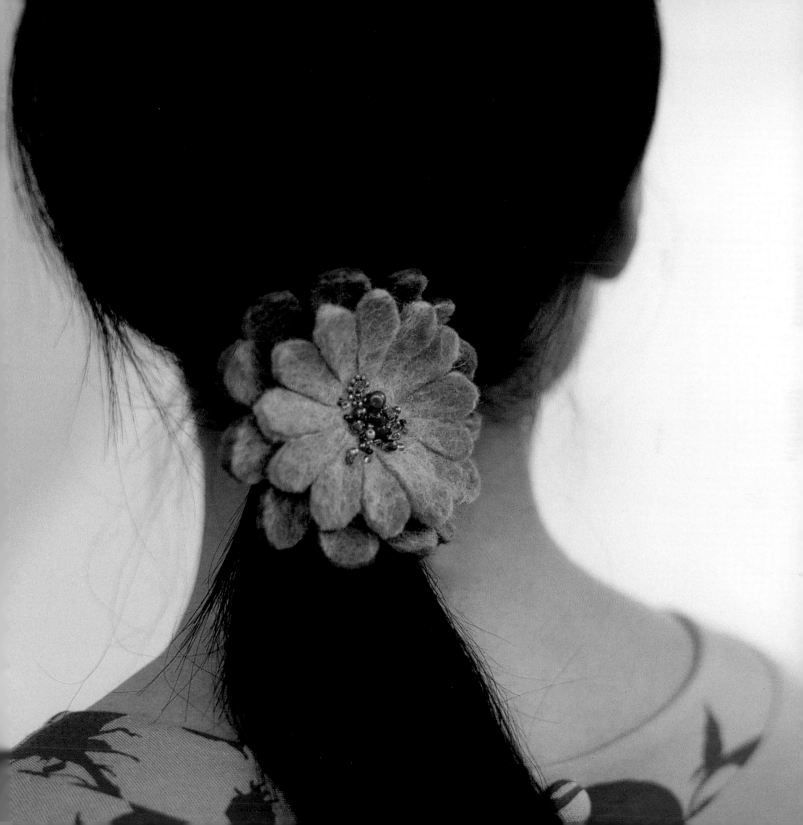

Materials

Merino wool tops:
 Small amounts of pink,
 orange, yellow, purple,
 turquoise and pale
 green

A matching hair elastic or
small barrette

Small selection of beads
and sequins

Fine needle and thread

Fabric or craft glue

Size
Approx. 8 x 8cm
(3¼ x 3¼in)

1 Make up a square measuring about 20cm (8in) with two layers of pink fleece and one of orange on top. Remember the felt will shrink. Add a wispy layer of yellow fleece radiating out from the centre.

2 Next to it, lay out a similar size square with two layers of purple and one of turquoise over the top. Then add fine wispy layers of pale green radiating out from the centre.

3 Cover both squares with a piece of netting, wet, soap and rub.

4 Rinse both squares in warm water and roll in a bamboo mat in all directions on both sides, as described on page 25.

5 Pour boiling water over the felt. Leave to cool slightly, and then rinse with cold water. Repeat the hot water rinse and then repeat the rolling process. The felt should have shrunk and become a lot harder. Make sure all soap has been removed from the squares and leave them to dry. Press them flat if necessary.

6 Draw a 7.5cm (3in) diameter circle on a piece of paper, cut out as a template and place it over the centre point of the blue felt. Cut out the blue circle. Make a second circle 6.5cm (2½in) in diameter and repeat for the orange felt.

7 To form the petals, make a series of cuts 2.5cm (1in) long from the edge towards the centre, spacing them equally about every 12mm (½in) around each circle. Then simply round the outer end of each petal with a small pair of sharp scissors. If you find it easier, you could mark the petals out with small pins or a chalk pencil before you start to cut.

8 Place the flowers on top of one another with the blue one underneath and sew them together. Using a fine needle and thread, stitch a selection of beads and sequins randomly in the centre of the top flower.

9 Cut a small circle of felt about 2.5cm (1in) in diameter from a piece of the remaining felt. Stitch the hair elastic onto the back of the blue flower, then glue the small circle of felt over the top to hide the stitching, using craft or fabric adhesive. Alternatively, glue the hair accessory onto a barrette.

Felt Down

When making simple flat felt, it is fine to work directly onto a bamboo mat, but sometimes placing netting on top of it first will help you to see what you are doing and will prevent fibres from becoming trapped in the mat.

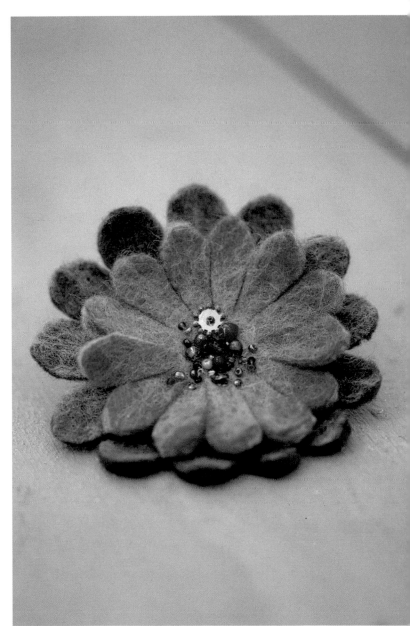

beginner

paper chase

Imagine having a constant supply of handmade felt greeting cards in your drawer ready for any occasion, including Happy Feltmaking Day! A good way of learning the feltmaking process is to make this simple two-layer piece of flat felt, which can then be adhered to a card. Once you've made one, you'll be inspired to create more.

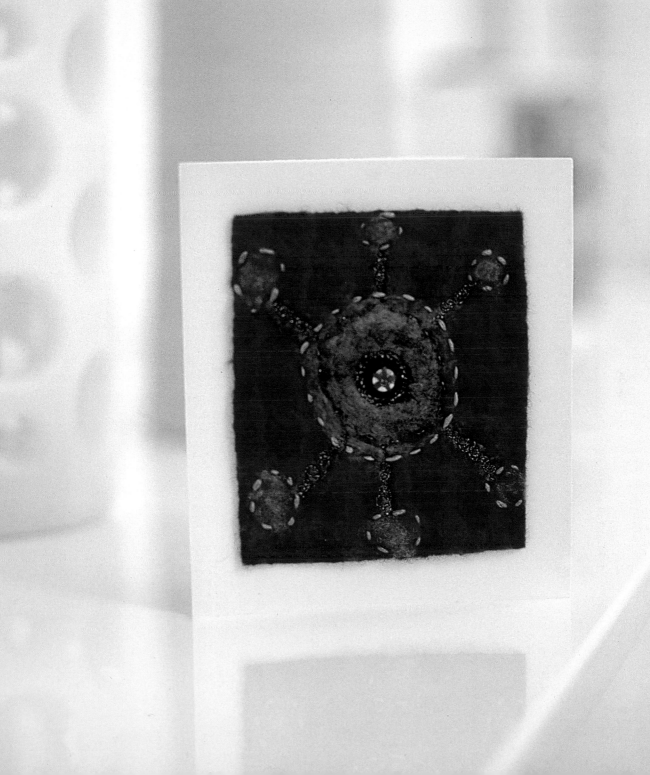

Materials

Merino wool tops:
 Small amounts of lime,
 cherry red, orange,
 green, pink, yellow,
 pale blue and dark blue

A needle and pale blue,
pink and orange
embroidery threads

Sewing machine and
machine embroidery
thread (optional)

Blank card

Fabric or craft glue

Size
10 x 8cm (4 x 3¼in)

1 Lay out a thin layer of cherry red in one direction and then another in the opposite direction, to create a rectangle measuring about 17.5 x 12.5cm (7 x 5in).

2 Lay out vertical and horizontal stripes of orange over the top to create a chequered effect as a background. Next lay out a thin star in green, with a large circle of blue in the centre. Highlight the blue with the light blue here and there, then outline it with a yellow edge. Add a dark red spot in the centre. Add pink spots at the points of the green star.

3 Cover, wet, soap and rub until there is no movement of fleece in the design.

4 Rinse the felt in warm water and then roll it in a bamboo mat in all directions on both sides.

5 Pour boiling water over the felt, then cold water and then hot water again. Rinse it well, making sure to remove all the soap.

6 Repeat the rolling process again until you are happy with the amount of shrinkage and the size of your piece.

7 Leave the piece of felt flat to dry, or press it with the iron on a wool setting. Once the felt is completely dry, thread a needle with pale blue embroidery thread and embroider a line of simple running stitch around the outside of the central circle. Do the same in pink thread around the pink blobs at the points of the star.

8 Add a sequin with a seed bead on top in the centre of the motif, using orange embroidery thread.

9 Using a sewing machine, stitch a random swirly pattern over the green star. Consider testing the tension and pattern on another piece of felt or other material first. The tension of the stitches made by the machine stitching will give the felt a quilted effect.

10 Trim the edges of the felt as required and stick it onto the front of your blank card with fabric or craft glue. Voilà – you're in business!

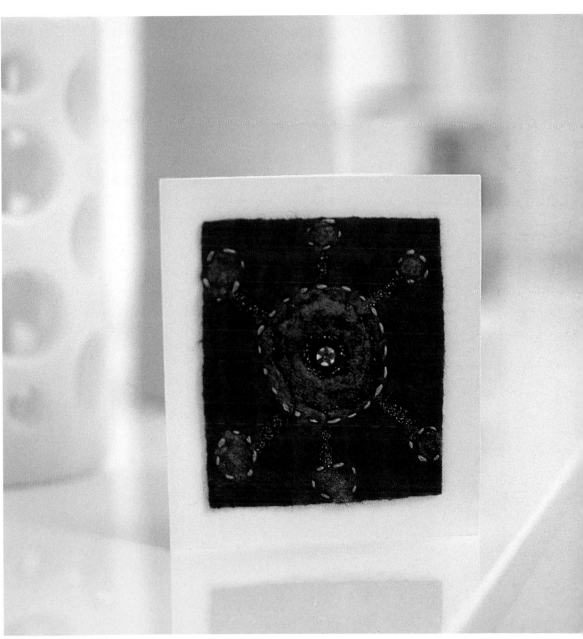

intermediate

full bloom

Whether you're serving afternoon tea or hosting a
Sunday brunch, this striking table runner makes an
unforgettable centrepiece. Blossoming pansies in
saturated hues come to life when set against a sprightly
polka dot background. Spraying the table runner with
fabric protector will protect it against unforeseen spills
and stains.

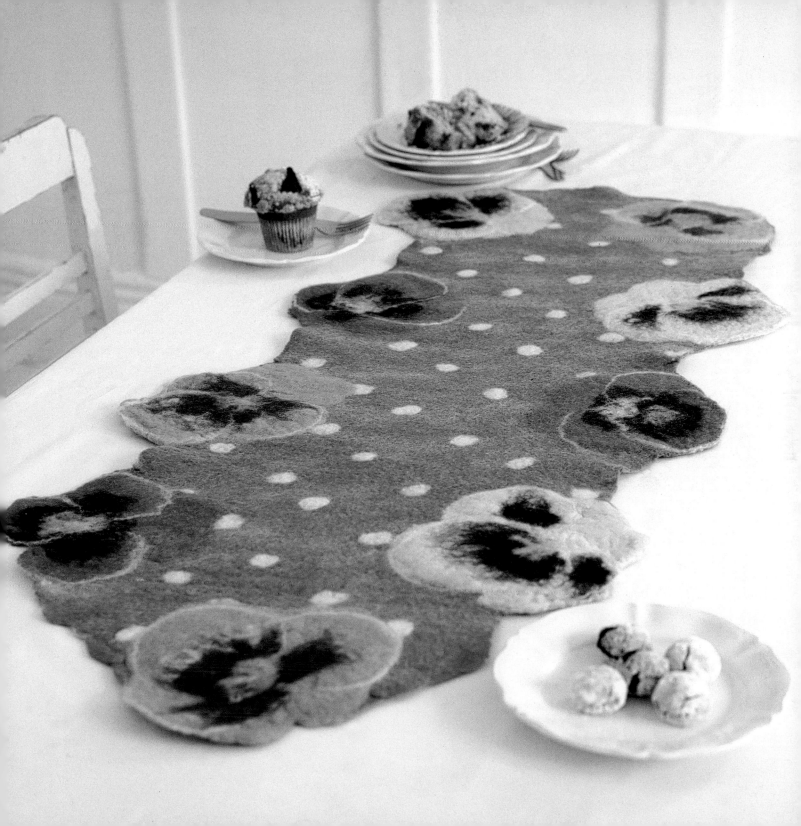

Materials

Merino wool tops:
 100g of white and sage

 50g of pale yellow, pink and purple

 Small amounts of bright yellow and lime green

Size
At widest part
50 x 118cm (20 x 47in)

1 Working directly onto a bamboo blind, lay a wispy layer of white fleece in one direction to form a rectangle measuring approximately 60 x 140cm (24 x 56in). Remember always allow for shrinkage with measurements, so the final table runner will be approximately 20% smaller than this, depending on how long you work on it. Round the ends of the rectangle.

2 Lay a solid layer of green in the other direction over the top, until the white fleece is no longer visible. Add six rows of white polka dots on top of the green fleece, positioning them so they run diagonally (see photo). Remember to keep the fleece for the dots as 'open' as possible to help them to felt.

3 To create each flower, make four rounded teardrop-shape petals with the main colour fleece, folding it around to achieve the rounded petal shape. Overlap each petal to form the flower, with bottom, two side petals and a top one. Outline each petal with a narrow white line to help define the edge. Use a contrasting colour fleece to create the centre, with veins running into the petals. Use small amounts of bright yellow and green for the centre highlights. Trim with small scissors if necessary. Repeat this step until you've made three flowers in each colourway.

4 Alternate the flowers around the edge of the runner, with each flower facing in a slightly different direction. Place the flowers so they hang slightly off the edge of the runner.

5 Cover, wet, soap and rub until the fleece no longer moves around. Apply more pressure and soap on the polka dots if they refuse to stay put.

6 Rinse briefly in warm water, taking great care as the runner will still be very fragile.

7 Using the bamboo blind, roll in all directions and on both sides. Then take the runner to the sink and pour boiling water over it. Leave for a couple of minutes and then rinse in freezing cold water. Make sure all soap is removed at this point. Repeat the hot/cold water step again. While the runner is still warm repeat the rolling process again, remembering to roll more in the direction requiring more shrinkage.

8 Leave the runner to dry, then press flat with an iron if required.

Dry Spell

Felt can be spun dry in the washing machine to remove excess water and speed up the drying process. Just remember not to set the machine to wash, as this could produce very different results!

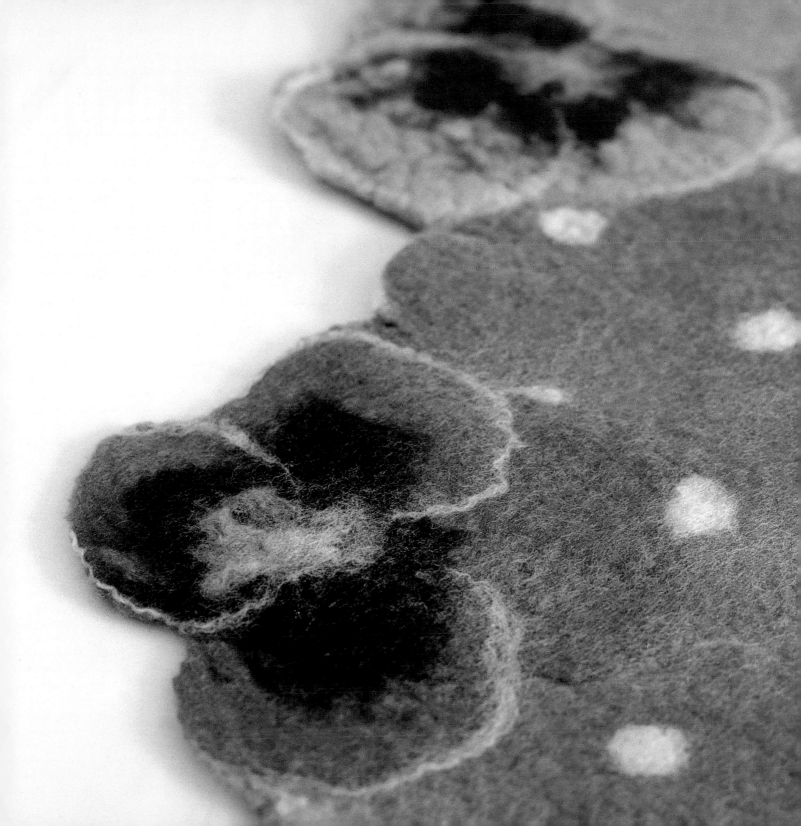

beginner

ewe and me

This decorative wall hanging accents bare walls while paying homage to our favourite provider of fleece. Interestingly enough, the body of the sheep is actually made from silk noil, but feel free to substitute it with any contrasting natural wool, such as Wensleydale, for a subtler effect.

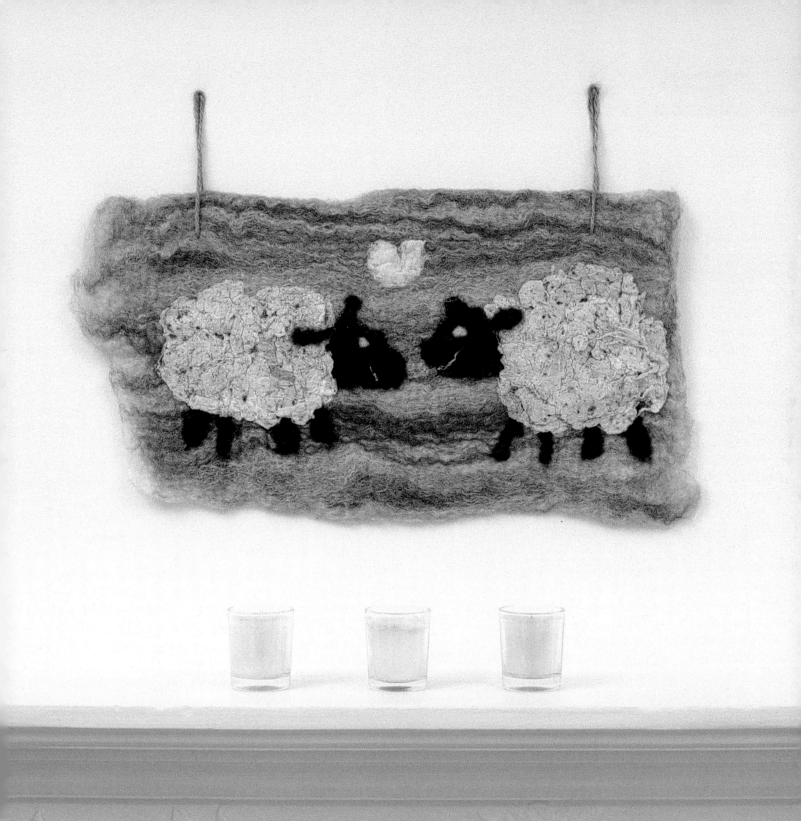

Materials

50g of Merino wool tops in white

50g of Jacob humbug in a natural pale brown colour

Small amounts of Black Welsh wool tops in black (or substitute with dark brown Merino)

50g of silk noil

Yarn or string for the hanging loops

Size

24 x 41cm (9½ x 16½in)

1 Working directly onto a bamboo blind, lay a vertical and wispy layer of white fleece in a rectangle measuring approximately 42 x 25cm (17 x 10in). Always remember to allow for shrinkage with your measurements.

2 Make a layer using the Jacob humbug, running it horizontally. This lovely wool is striped, but if you can't obtain any, use a medium brown wool that will contrast well with the other colours you are using. You need to make sure that the sheep will stand out well from the background.

3 Now make two sheep facing each other. Lay out some silk noil to form the bodies, then make little legs, heads and ears from the Black Welsh. Use small amounts of white fleece to form mouths and eyes. Using more white fleece, create the little heart shape to put above sheep – after all, they are in love.

4 It is important to trap the silk noil onto the fleece. As silk noil is not wool, it will not adhere to the fleece underneath, so you must lay a few very wispy strands of fleece over the top of it to keep it in place.

5 Cover, wet, soap and rub until the fleece no longer moves around.

6 As the sheep are still very fragile, carefully rinse the wall hanging briefly in warm water.

7 Roll the wall hanging up in the bamboo blind and roll it in all directions and on both sides. Take the project to the sink and pour boiling water over the top. Leave for a couple of minutes and then rinse in freezing cold water. Make sure all the soap is removed. Repeat the hot/cold water step. While the piece is still warm, repeat the rolling process again.

8 Leave to dry, then press flat with the iron on a wool setting if needed.

Trap it in

Try trapping all sorts of different things in your feltmaking. Leaf skeletons, silk, glitter, yarns and dry petals will all work beautifully. Just make sure that very small amounts of fleece – either the same colour as the item or the background colour – are placed over the top of whatever you are trapping. You will barely notice this fleece on the finished article, but what you have trapped in will add texture and interest to your work.

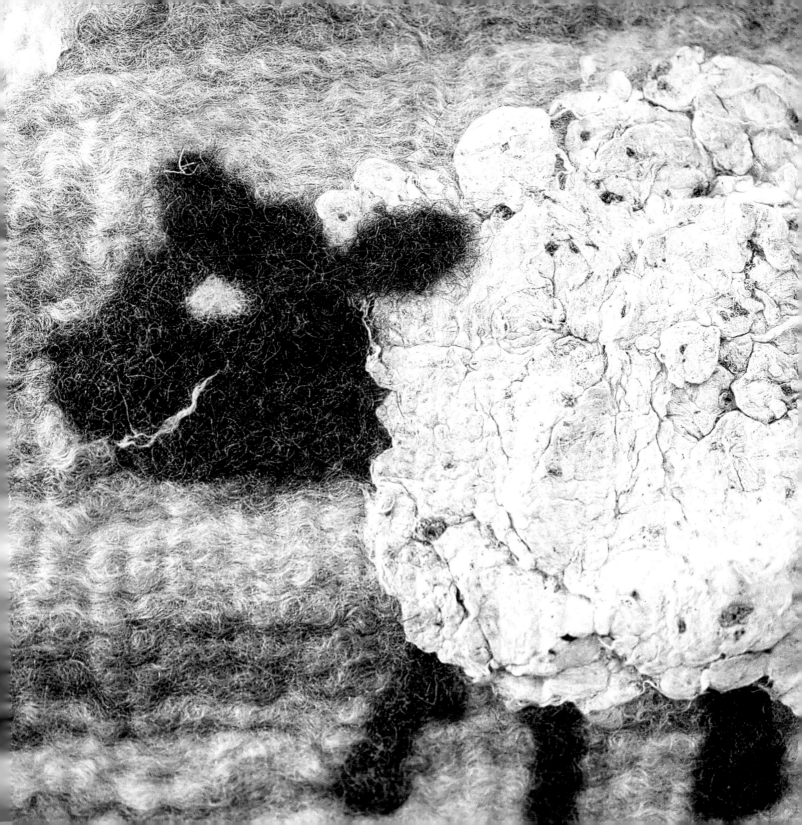

beginner

heartfelt rug

You'll never get out of bed on the wrong side again when you step straight onto this cosy mat from oh-so-soft Merino wool. If you're making a rug for a corridor or a hallway with plenty of foot traffic, consider felting with a more robust wool such as Finn or Icelandic, which pills much less.

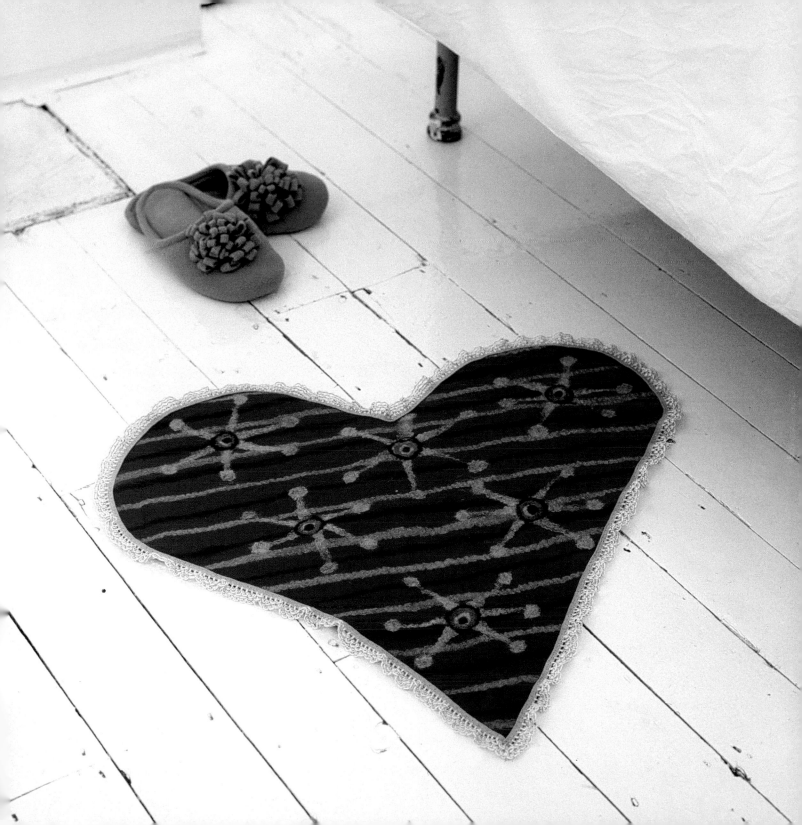

Materials

Merino wool tops:
 100g of cerise

 30g of dark magenta
 and peach

 Small amounts of dark
 green, sage green, lime
 and olive yellow

Lace or frilled fabric trim

Non-slip rug backing

Size

At widest part 67 x 67cm
(27 x 27in)

1 Working directly onto a bamboo blind with the cerise fleece, lay out the outline of your heart to about 80cm (32in) high and the same width. Remember it will shrink, and that you can trim it to size! Fill in the outline, placing the fleece vertically down the heart. Still using cerise, make another layer in the opposite direction, and then a third layer in the original direction. A rug needs a minimum of three layers – and if for a busy room, then maybe four or five layers.

2 Add stripes of dark magenta and peach across the heart. Place six star shapes in lime fleece and add a coil of dark green and a coil of sage green in the centre. Add olive yellow spots on the points and in the centre of each star. Finally place a small amount of dark magenta right in the centre of each star.

3 Cover, wet, soap and rub until the fleece no longer moves around.

4 Rinse briefly in warm water, taking great care as the rug is still quite fragile.

5 Roll in all directions in the bamboo and on both sides. Now take the rug to the sink and pour boiling water over the top. Leave for a couple of minutes and then rinse in freezing cold water. Make sure all soap is removed at this point. Repeat the hot/cold water step again and while the rug is still warm repeat the rolling process again.

6 Leave the rug to dry, then press flat if required, with the iron on a wool setting.

7 Machine or hand-sew your lace or frilled fabric trim all around the edge of the heart.

8 Attach a non-slip backing to your rug.

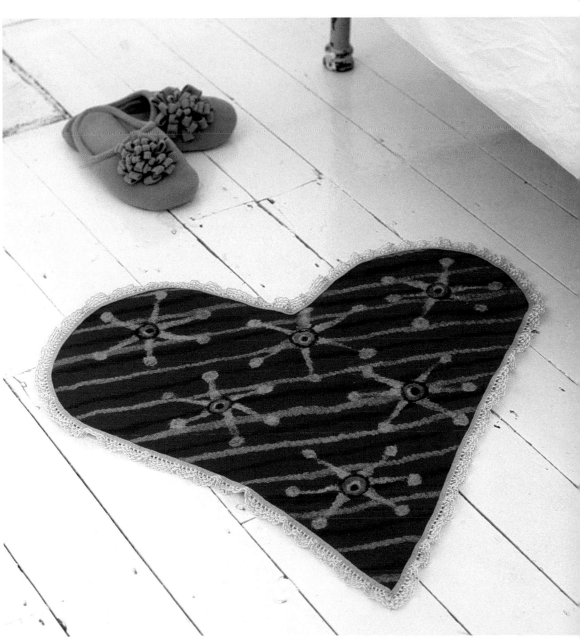

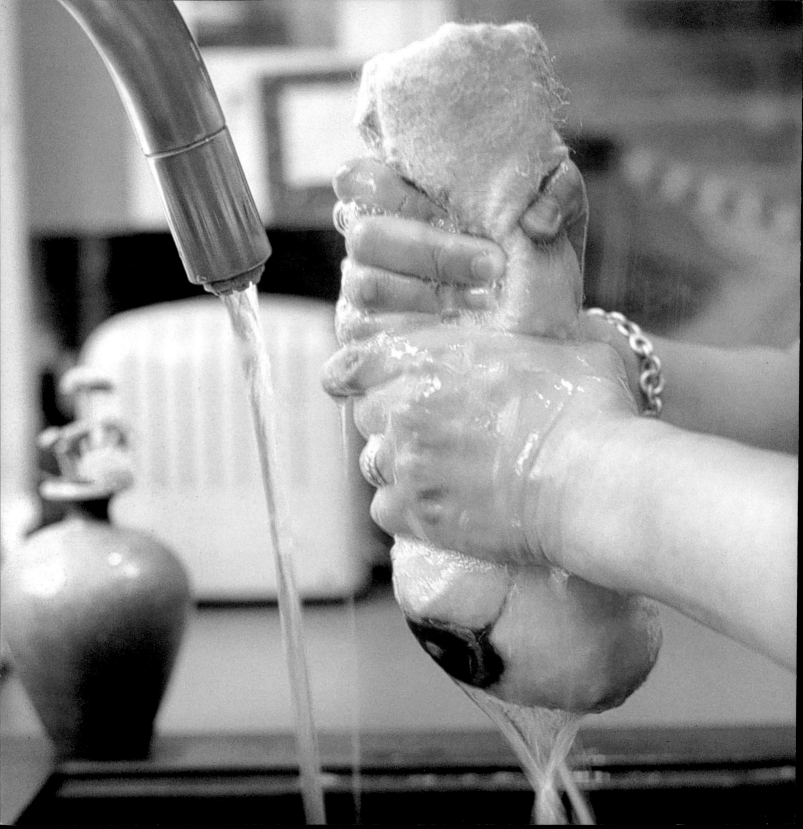

3-d shapes

Having mastered the flat feltmaking process, move
on to working with felt in more of a sculptural way.
Hand-rolled felt lends itself wonderfully to seamless
3-d forms and shapes, with most projects being worked
around plastic templates and forms. As the fleece is
manipulated around the templates, a strong seamless
piece of felt is created, which is completely reversible
once the template is removed. Another bonus is that
there is no sewing involved!

Technique 1: Hollow Forms

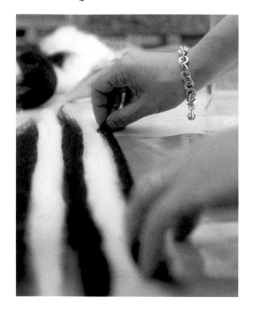 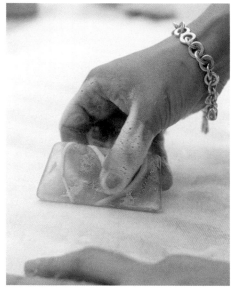 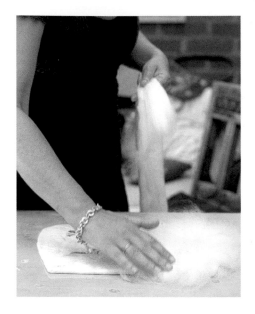

1 Laying inside layer

Start to lay wispy pieces of fleece in one direction across the template. It is important to understand that you are working from the inside out so you are laying down the design for the INSIDE of your piece first. The black and white stripes shown here will be the 'lining' of this bag when finished. Make the lengths of fleece slightly longer than the size of the template so you have some overlap to fold over for your 'seams'.

2 Wetting/rubbing

Lay a large piece of netting across the fleece. Wet the fleece through the netting with warm soapy water. It is important to thoroughly wet the fleece, but equally important to make sure it isn't too wet by mopping up excess with a cloth. Gently rub a bar of soap across the top of the netting, then rub across the whole area for about five minutes. Remove the netting, being very careful not to pull the fleece away from the template underneath.

3 Laying 2nd layer

Turn the fleece and template over and repeat step 1, laying down the design for the opposite side. When you have finished, fold over the edges from side one to create your 'seams' and repeat step 2 on this side. Remember you are working in reverse so you must 'think' from the inside outward. If you are making a design on the inside of your shape you MUST lay that design down on the second side BEFORE you fold over the seams from side one, otherwise the seams would be inside the design, concealing the edge of it.

Fantastic Plastic

Before you start, cut your template to shape from some strong thick plastic. Always remember to cut the template about 20% larger than you want your finished piece to end up, to allow for shrinkage.

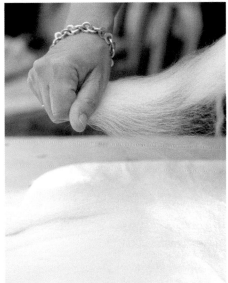
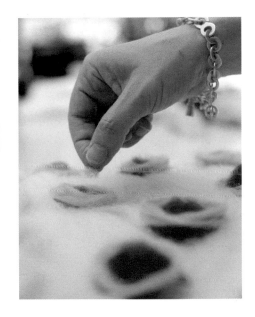

4 Laying middle layers

Turn everything over again. Using white for this middle layer, start to lay fleece in the opposite direction to layer one, covering the entire shape, again leaving extra to overlap for seams. Although the middle layer is hidden a vague hint of the colour may show through your final design, so bear this in mind. Repeat steps 2 and 3 for the middle layer. This time you can fold the seams over from side one before you lay down the second side, as you are now working on the middle layer that no one will be able to see.

5 Laying top layer

Turn over again and fold in the seams. Lay your final background colour out in the opposite direction to layer 2 (in the same direction as layer 1), again leaving extra to overlap around the edges.

6 Final design

Now lay your design on top. When you are happy with your layout put the netting over the top again and repeat step 2, but this time rubbing for much longer (about 10-15 mins) to firmly adhere the layers of fleece together. Plenty of pressure and enough soap is important. Make sure there is not too much residual water left in the layers of fleece – if you press down hard and a puddle forms, mop up the excess water with a cloth. If the fibres feel dry and springy in places, then add a little more water.

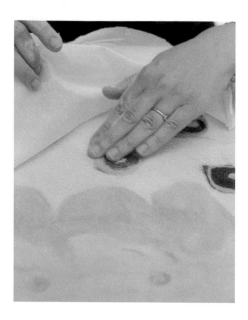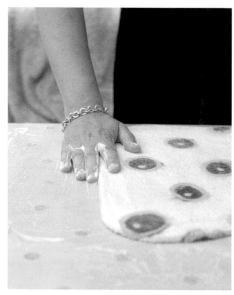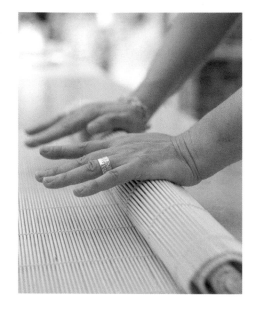

7 Fixing fibres

Peel back the netting and check that the fibres no longer move around when you rub your hand across them. If they do, continue the rubbing process until they're stabilized! Turn the piece over, fold over the seams and repeat steps 5 and 6. Since this is the last side, you do not need any extra for a seam overlap so you can trim off any excess fleece.

8 Rubbing edges

When the design is fixed in place on your final side, remove the netting and rub around the sides of the piece with a wet soapy hand until the edges are well felted together. Rinse briefly in warm water – don't leave under a running tap, as it is still quite delicate! Try and get most of the soap out now before you move on. Wring out well but gently.

9 Rolling felt

Roll up the felt in a piece of bamboo blind as tightly as possible and roll it backwards and forwards 20-30 times. Unroll, rotate everything clockwise 90° and repeat until you have rolled 20-30 times through 360°. Turn the piece over and repeat on the other side. Shrinkage occurs in the direction in which you are rolling, so roll the same amount in each direction for even results.

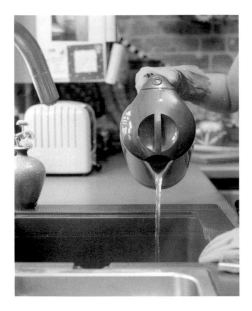

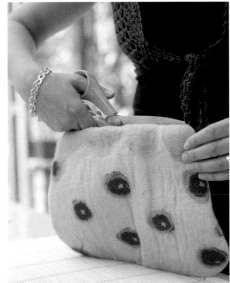

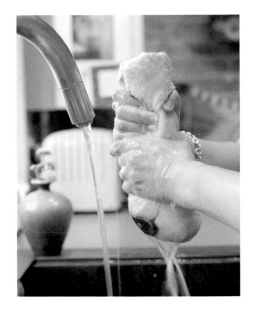

10 Rinsing

Wearing rubber gloves to protect your hands from the heat, place the felt bag in the sink and pour boiling water over it. Wait until it has cooled enough so you can touch it and then wring out. Roll again as in step 9, but this time, only 10 times in each direction.

11 Cutting

Cut open the top of the bag and remove the template. Trim the top edges straight if necessary, then rub gently inside and around the top with a wet soapy hand to felt the edges.

12 Final rinsing

Put the bag back in the sink and pour boiling hot water over it, rinse under the cold tap, then repeat with hot water again. Roll again for 10-20 times in each direction, depending on the shrinkage required. Stop rolling once your piece has reached the desired size and thickness. Do a final rinse in cool water to remove all soap. Lay flat to dry and press on wool setting to smooth and flatten if required.

Technique 2: Moulding 3-d Shapes

In this technique, mould two useful 3-d shapes from fleece by wrapping and compacting the fleece together slowly, thus eliminating all the air inside. As the wool shrinks and hardens, dense shapes can be formed simply by using just soap, water and friction. Here, a bead-sized ball and a bag handle are used to demonstrate the technique.

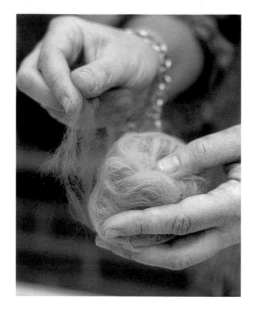

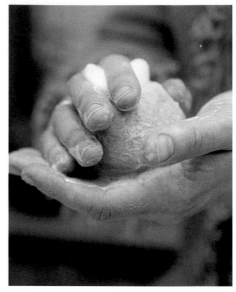

Cheat's Method

Make many felt balls at once by using the washing machine and some old nylon tights. Place a fleece ball into the toe of the tights, tie opening with an elastic and repeat up the legs! Pop into a 60°C (140°F) wash with soap powder, adding a pair of old jeans to create friction.

1 Making a ball

Coil up a little fleece to form a core and start to wrap more fleece around it. The ball will shrink dramatically – approx. 50% or more – so wrap the ball substantially larger than you want it to end up. Add different coloured fibres to create depth and patterns, and wrap a final wispy piece of fleece around it to keep everything in place.

2 Dampening

Using the soapy water mixture (see page 23), spray the ball until it is damp. Wet it sufficiently, but don't drench it in water as it is extremely fragile and will fall apart. Make your hands soapy, then roll the ball very lightly in between your palms, using as little pressure as possible. If it starts to resemble a small brain, release a little pressure. You don't want to squash it before it has started to harden sufficiently! After 5-10 minutes, you should notice the ball starting to feel harder and denser.

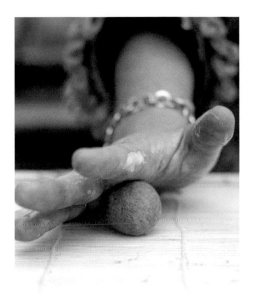 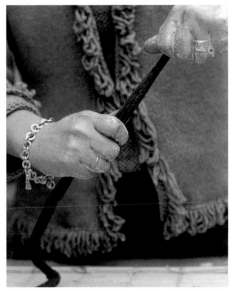 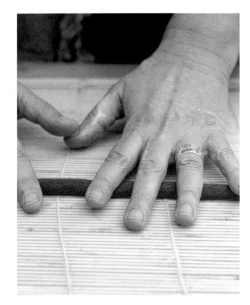

3 Rolling

Once the ball has hardened slightly, roll it gently on a bamboo mat. As the ball continues to harden, increase the pressure accordingly until it all comes together. Rinse thoroughly in hot or boiling water, taking care not to scald yourself and make sure to rinse out all the soap. Continue to roll on bamboo until the ball is reduced to the desired size.

4 Making handles

To make a fleece handle, pull off a length of fleece 20% longer than you want the handle to end up. Thoroughly wet it with warm soapy water from a spray bottle. Keep pulling the fleece length through your hand for about 5-10 minutes until you notice it begin to harden.

5 Rolling/rinsing

Start to roll it back and forth on a bamboo mat – gently at first and then applying more pressure as the handle gets harder and more compact. Rinse with boiling water, taking care not to scald yourself and then rinse in cold to ensure all soap has been removed. Continue to roll until your handle has reduced to required length and thickness.

intermediate
★★

highly strung

It's official – felt jewellery has arrived! Even if you've never considered tufted trinkets before, you won't be able to resist making an assortment of these tactile felt necklaces. Not only are the beads made of felt here, but the choker band and button fastening are too. Quite frankly, nothing else would do!

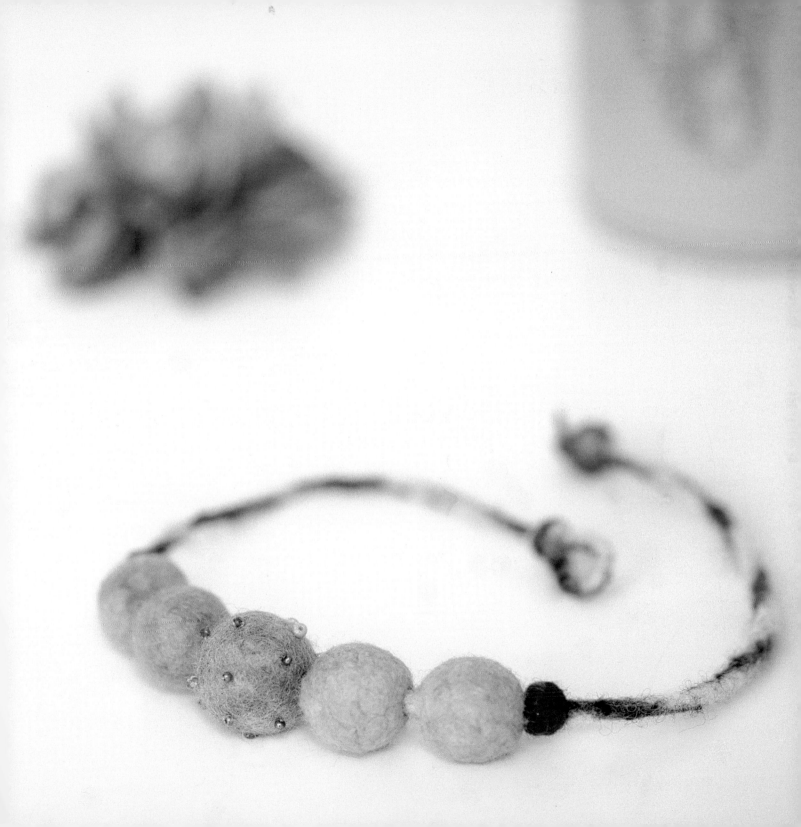

Materials

Merino wool tops:
 Small amounts in
 black, white, pale blue,
 pale pink, pale green
 and red

Fabric or craft glue

Large embroidery needle

Seed beads

Beading or sewing needle

Transparent or matching
thread

Size
Length 40cm (16in)

1 Start by making your fleece beads as described on page 52-53. I have made five for this choker but you could add many more and carry on all the way around. If you want all your beads to be the same size, first lay out the dry fleece for all of them at the same time, making sure you use the same amounts for each.

2 Make a smaller red bead, which will act as your button to fasten the necklace. Then make the felt band on which the beads will all be threaded, using the felt handle technique on page 53. You need this to be approximately 40cm (16in) long when finished, so start off with fleece about 55cm (22in) long and trim it down. You can make the band as wide as you like, but remember the thicker it is, the harder it may be to thread your felt beads. I've gone for a finished thickness of about 4mm ($^1/_8$ in), which I just about managed to thread through a large embroidery needle, but any thicker and you may need a bodkin or upholstery needle.

3 Leave all the felt pieces to dry thoroughly. Thread the felt choker band through the eye of a large embroidery needle. Work this through the small red bead first and then through the centre of the other beads in your preferred order.

4 Make a small loop at the end of the band, at the opposite end to the red bead. It should be large enough for the bead to fit through, but not so big that it will come undone. Glue it in place and sew a few stitches as well to secure it. Slide the small red bead right to the other end and tie a knot to prevent it from slipping off. Add a dab of glue underneath to secure it in place.

5 Sew contrasting seed beads into place on the biggest bead in the centre.

The Bead Goes On

Why not experiment by cutting beads in half or slicing them through into sections? If you use a contrasting colour wool in the centre, this inner colour will be exposed when you cut through, revealing interesting patterns.

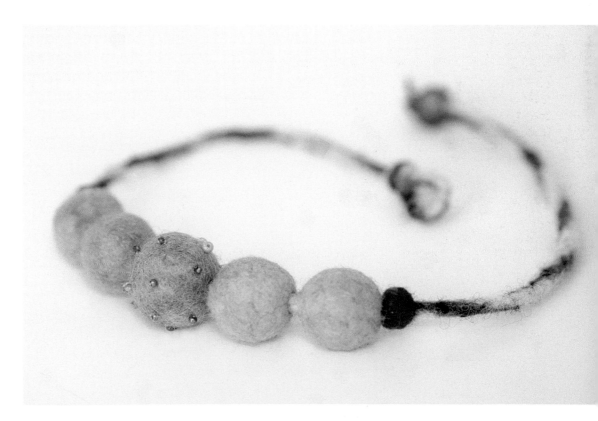

intermediate

★★

dotty spotty

No woman can ever have too many handbags and this one is definitely spot on! Create this stylish design with short handles or a longer shoulder strap and prepare to turn heads and attract attention wherever you go!

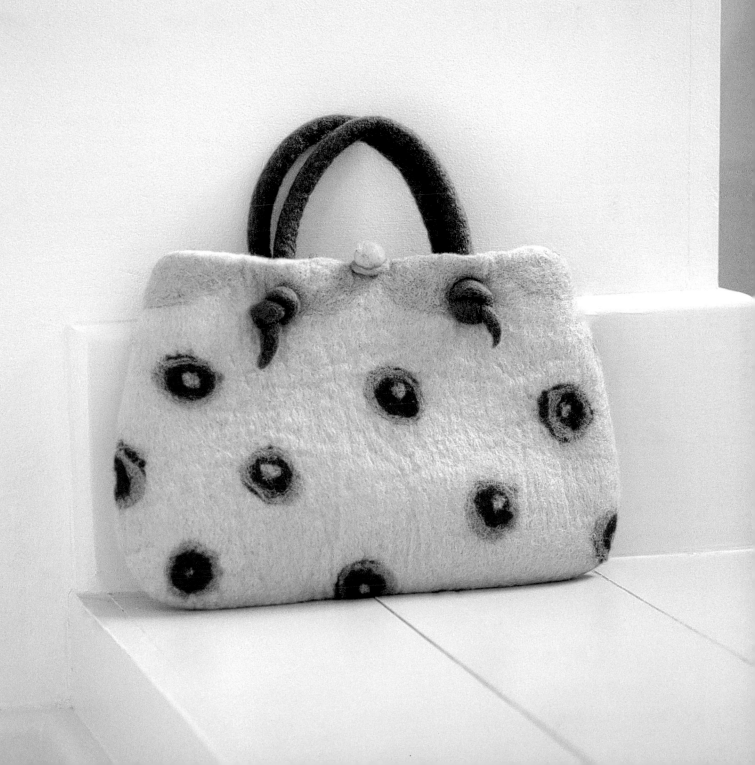

Materials

Merino wool tops:
 50g of black, white, pale lime

 Small amounts of pale blue, candy pink and cherry red

Strong plastic for template

Some purple wool for handles

Some yellow wool for the ball button

Some peach wool for a loop, or a small piece of cord or ribbon.

Size
Excluding handle
20 x 30cm (8 x 12in)

1 Using the bag template on page 154, enlarge by 200% or to at least 20% bigger than you intend your final bag to be, to allow for shrinkage. Cut out the shape in strong plastic.

2 Lay black and white stripes of fleece running vertically over the template, leaving approximately 5cm (2in) extra overlap around the template.

3 Cover, wet, soap and rub as shown on page 48. Turn the template over and repeat, laying the stripes vertically on the other side before folding over the seam overlap.

4 Lay the white fleece horizontally for the middle layers on both sides, folding in your overlap each time you turn the template over.

5 Layer the pale green fleece vertically as the final layer. Make large red spots and space them equally over the top, then add a pink coil around each one and a small blue centre. Complete with a scalloped blue pattern around the top edge.

6 Cover, wet, soap and rub until the fibres are stuck fast and the design no longer moves when brushed over with your hand. Repeat the final design on the other side of the bag, remembering not to leave an overlap on the last side. Trim off excess fleece. Soap the edges and rub until they harden slightly.

7 Rinse the bag briefly in warm water and then do a complete roll as described in step 9 on page 50.

8 Pour boiling water over the bag. Roll ten times in each direction and then cut the top of the bag open with sharp scissors and remove the template. Trim to neaten edges if necessary and then soap the edges and rub them until they felt. Soap and rub the inside of the bag if any of your inner design is still moving around.

9 Rinse the bag in hot water again, then freezing cold, then hot. Roll until you are happy with the size and shape.

10 Rinse in lukewarm water to remove last traces of soap. Leave flat to dry, or lightly press with the iron on a wool setting. Alternatively, spin dry in a washing machine.

11 Make handles and a button (see page 53). Attach the button to the top front of the bag, and make a small felt loop (a very small version of the handle) or attach a piece of cord or ribbon to fasten the button. Make small incisions at handle points, and feed handles through. Tie a knot outside the bag at either end of each handle and trim.

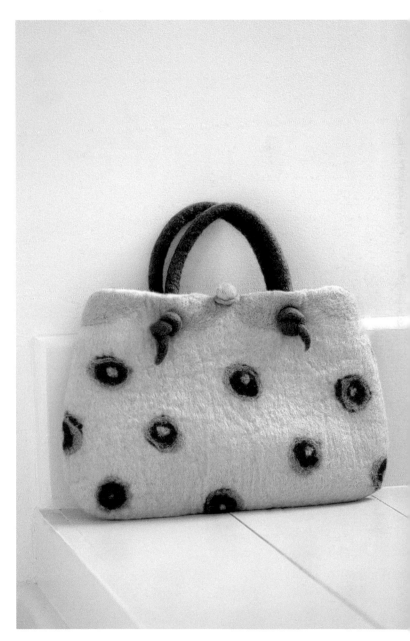

intermediate
★★

cutie booties

Create these adorable cosy baby booties using a double ended foot template which is snipped in half at the end. Parents will gush and very small people will give you a congratulatory gurgle!

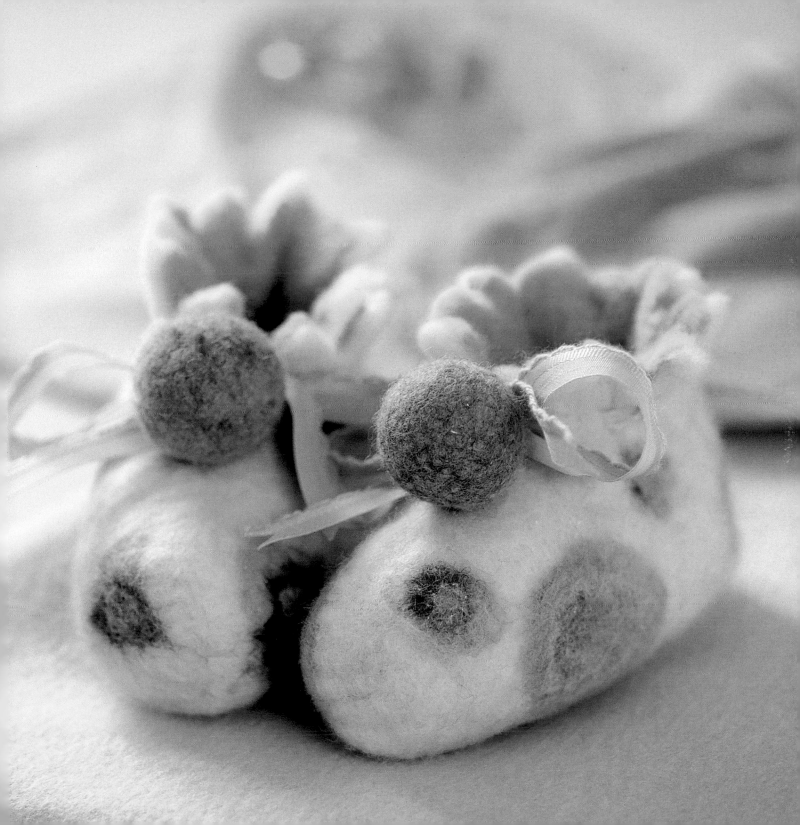

Materials

Merino wool tops:
 50g white and
 peppermint green

 Small amounts in pale
 blue, pale pink, pale
 lime, pale yellow and
 red

Glitter strands

Ribbon

Embroidery needle

Needle and thread

Strong plastic for template

Size
Length 12cm (4¾in)
Width 5cm (2in)
Height 8cm (3¼in)

1 These booties are two layers thick. Using the template on page 155, enlarge in size by 200% or by at least 20-30% bigger than you want the booties to end up. Then trace your template onto strong plastic and cut.

2 Next lay a layer of peppermint green fleece in one direction over the top of the template, remembering to leave overlap. Cover, wet, soap, and rub for a few minutes. Turn template over, fold in the edges and repeat.

3 Turn the template over again, fold in the edges, and lay a layer of white fleece in the opposite direction. Cover, wet, soap and rub. Turn over, fold in edges and repeat.

4 Lay the design on top using wispy circles of the other colours, randomly layered on top of one another. Add in a few glitter strands at this point and make sure you trap them in with a little more wool fleece. Cover, wet, soap and rub until the design no longer moves around when rubbed across with your hand.

5 Fold over the edges and repeat step 4 on the other side, remembering no overlap is required on this final side.

6 Rinse briefly in warm water, taking care as the booties are still very delicate.

7 Do a complete roll on both sides (see page 50, step 9) then a boiling water rinse. Roll briefly on all sides and then cut the double-ended foot shape cleanly in half and remove the template from each foot. Using some small scissors, cut a zigzag around the top of each bootie and then add a little soap and rub to felt the edges.

8 Pour boiling water over the booties. Leave for a few minutes, then rinse under a freezing cold tap. Remove all soap and repeat the hot water again. Do another complete roll on both sides, or until you are happy with the fulling and shrinkage.

9 Leave to dry. Start to make two felt balls (see page 52), using the white fleece as a base, and then wrapping strands of the pale green and pale pink fleece over the top.

10 Measure out your ribbon and cut into two pieces, making sure they will be long enough to tie into a bow at the front. Thread the ribbon through an embroidery needle and sew it in and out around the top of each bootee. Once the felt balls are completely dry, attach them to the top of the booties with a needle and thread.

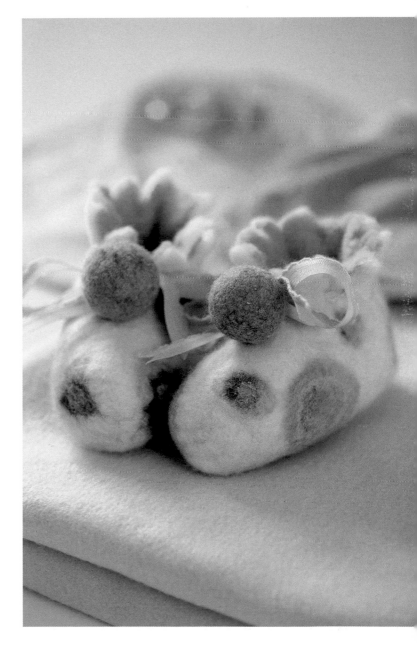

intermediate
★★

tea time cosy

When it's time for a cuppa, everyone knows it tastes much better brewed in the pot. With this in mind, I have designed this tea cosy to keep your teapot feeling warm and safe, and to preserve your integrity as a lea maker. Feel free to change the colours to match your kitchen, your teapot or your tea.

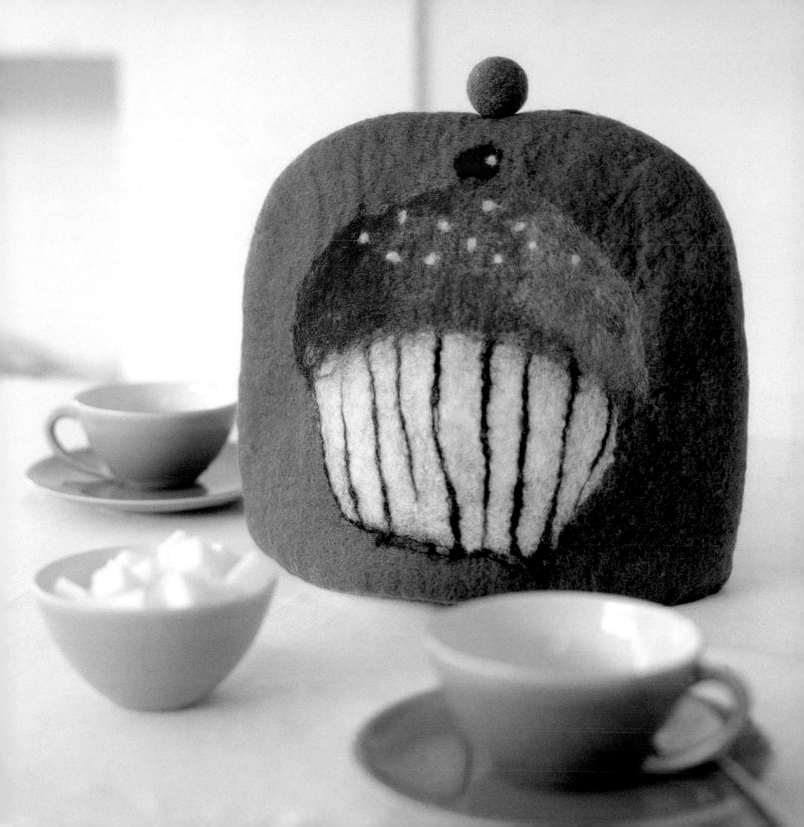

Materials

Merino wool tops:
 100g of turquoise

 50g of green

 Small amounts of white,
 dark pink, light pink,
 red and black

Needle and thread

Strong plastic for template

Size

Approx. 26 x 34cm
(10½ x 13½in)

1 Using the tea cosy template on page 155, enlarge by 200% or measure your potential teapot and then increase the size accordingly. Trace your template onto some strong plastic and cut out.

2 This tea cosy is three layers thick. Start by laying down the green fleece for the inside of your tea cosy, overlapping the template at the edges. Cover, wet, soap and rub for a few minutes. Turn the template over and fold in the edges. Repeat the inside fleece layer on the other side. Now lay down your middle layer in turquoise wool in the opposite direction on both sides as above. Turn over again and fold in edges. Now lay the top layer of turquoise fleece in the original direction on top. Cover, wet, soap and rub.

3 Now you are on the final side, and will not require any overlap. Lay out the turquoise fleece as a background, then lay white fleece to make the cupcake case. Lay wispy black stripes over the top to indicate the ridges. Add dark pink and light pink fleece for the icing, graduating from light to dark and accenting small white icing decorations on top. Finally, create a red cherry, highlighting with some white.

4 Once you are finished, cover, wet, soap and rub for about 10 minutes, or until the fleece cupcake is secured in place.

5 Briefly rinse in warm water then do a complete roll on both sides in the bamboo mat. Pour boiling water over the cosy and leave. Now roll briefly on both sides.

6 Carefully cut open the base of the tea cosy and remove the template. Trim the edges to neaten, and soap, rub and felt the edge.

7 Now pour boiling water over the cosy again, leave for a few minutes, then run under a freezing cold tap. Make sure all traces of soap are removed. Repeat the hot water again, and then do another complete roll on both sides (see page 50, step 9), or until you are happy with the amount of shrinkage.

8 Leave to dry and press flat if required, with the iron on a wool setting.

9 Start to make a felt ball for the top of the tea cosy (see page 52) using the turquoise fleece with a little pink in it, or you can use a contrasting colour if you prefer. Once everything is dry, attach the ball to the top of the cosy with a needle and thread.

10 Have a nice cup of tea.

intermediate
★★

dapper flapper

This flower-accented cloche is a striped sensation that's perfect for rain or shine as the felted fabric makes it water-resistant. If you cannot find a polystyrene block, you can use a suitable size bowl or ball instead.

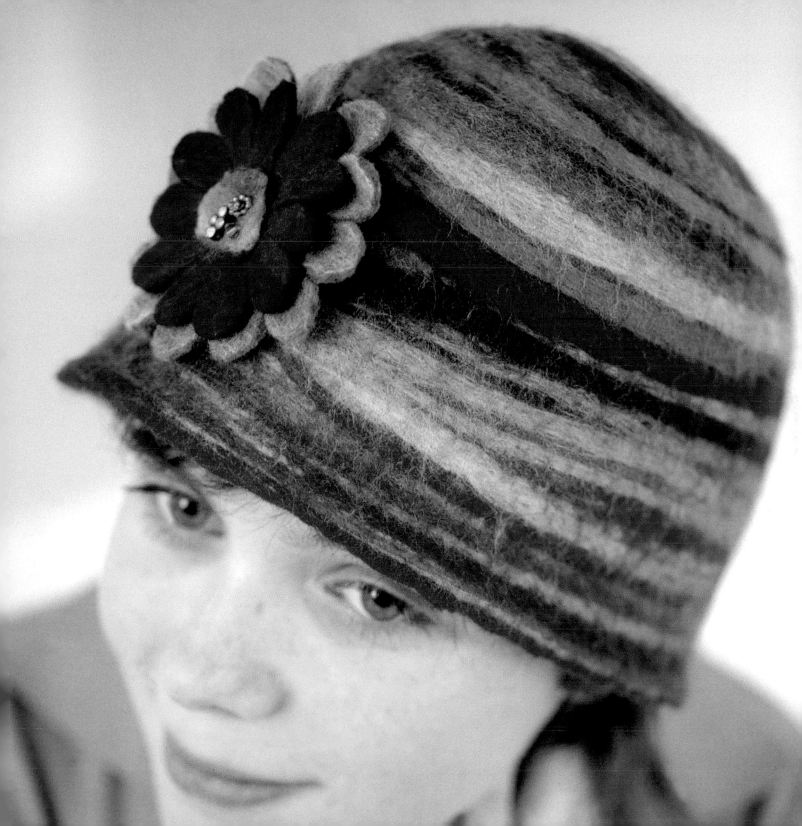

Materials

Merino wool tops:
 75g of bright pink

 25g of assorted colours

Small amount of Blue
Faced Leicester wool tops
or other natural brown

Spray starch

Vintage buttons/beads
(optional)

Needle and thread

Pins

Strong plastic for template

A hat block or a head-size
bowl or ball

Size
Approx. 15 x 23cm
(6 x 9¼in)

1 Measure your head circumference and divide in two. Using the template on page 158, enlarge it to 15-20% wider than the measurement above. My head measured 60cm (24in) around, so I made my template 36cm (14in) wide. Make the template (see page 154) about 34cm (13in) high to give you plenty of excess to turn up as a brim or trim off.

2 This hat has been made two layers thick, but you can add an extra layer in the middle. If you only use two layers like me, be sure to layer the fleece thickly and evenly without any gaps. Layer up some bright pink vertically over the template for your first layer, leaving overlap around the edges. Cover, wet, soap and rub. Turn over, fold in edges and repeat on the other side.

3 Turn over the template again and fold in the edges. Now start to lay out the stripes running horizontally around the hat. Using as many colours as you want to, continue until you achieved the desired effect and can no longer see the pink underneath. Add in a few strands of Blue Faced Leicester here and there as a contrast.

4 Cover, wet, soap and rub until there is no movement of fibres when you brush over the design with your hand. Turn over the template and fold over edges.

5 Try and keep the flow of stripes on this side of the hat, so it looks like a continuous pattern. Lay out the stripes, remembering that no overlap is required as this is the final side. Cover, wet, soap and rub as before.

6 Rinse the hat briefly in warm water to remove some of the soap and then do a complete roll (see page 50, step 9). Pour boiling water on top of the hat, leave a few minutes then roll briefly on both sides.

7 Remove the template. Pour on more boiling water, then freezing cold. Remove all soap and repeat the boiling water again. Continue rolling, but keeping an eye on shrinkage here. Should the hat start to look a little smaller than you want it, stop rolling! It can be stretched out quite a bit while it is still damp, so put it straight onto the hat block.

8 Spray with starch, then carefully use a steam iron over the hat to help mould it to the shape of the block. Keep spraying and smoothing until you are happy. Leave the hat on the block to dry. Try on, use pins to mark the correct length or brim, and trim as necessary.

9 Make two flat felt flowers (see page 26) and attach them off-centre at the front of the hat with a needle and thread. Add a small circle from the excess trimmings and finish with some vintage beads.

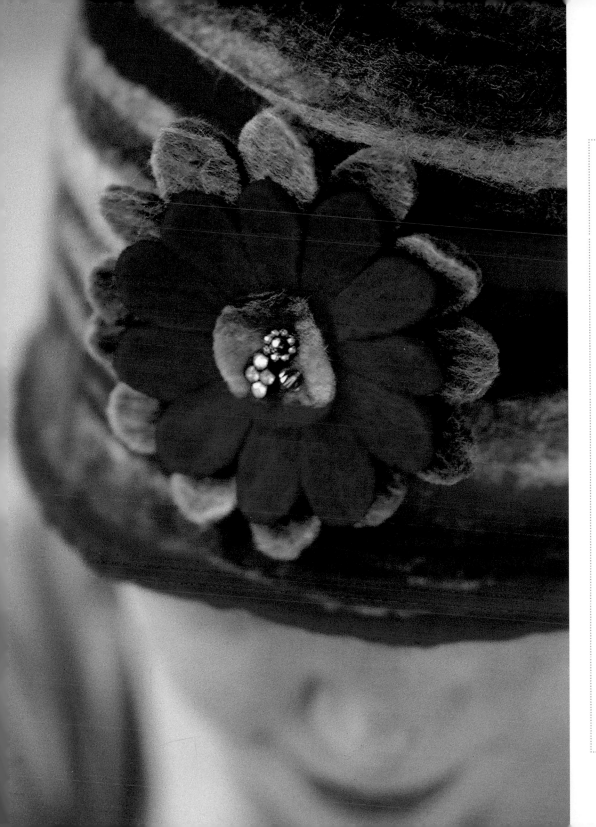

Block Party

Another way of making a hat over a block is to start by making a large square of flat felt. Just after rolling it, place it centrally over the block. Add more soap at this point, then start to rub and mould the felt over the block. Try and get rid of any wrinkles by pushing them downward, continuing until the hat looks smooth all over. Now add some really hot water and continue to rub hard, if necessary placing a piece of netting over the hat to stop the fibres moving. Once the hat feels well felted and has shrunk a little, rinse out all soap with cool water. Trim, then place back on the block, spray with starch and iron carefully with a steam iron. Leave to dry.

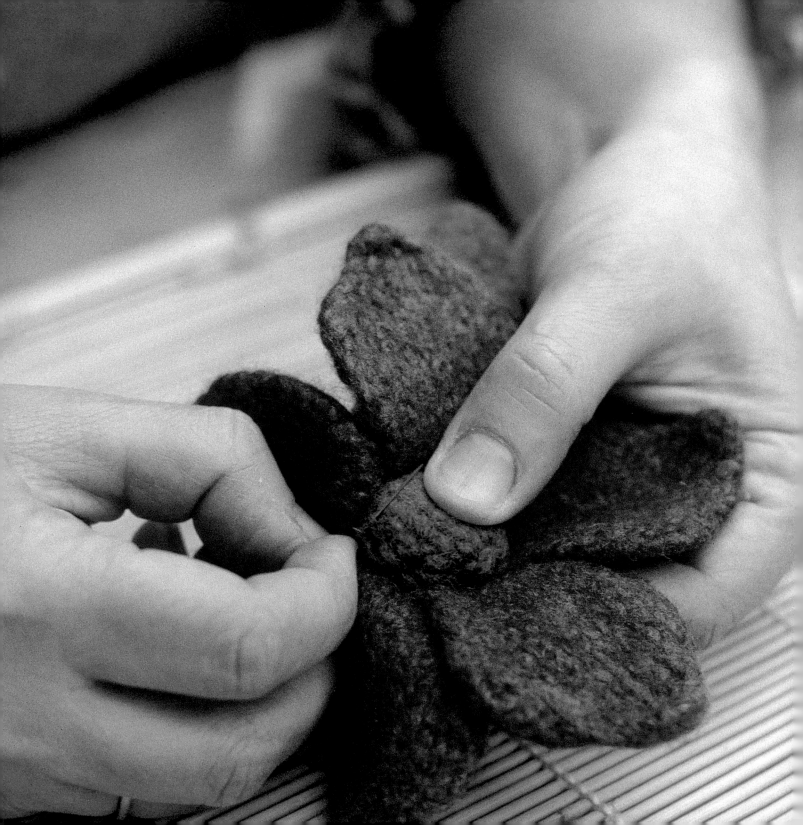

knitted felting

Knitting is a popular art form in itself – but now elevate that onto a higher level by transforming your knitting into felt. By knitting with interesting coloured yarns, you can take advantage of the different patterns, textures and colour combinations that are created after felting, which are often quite different to those possible using conventional feltmaking methods.

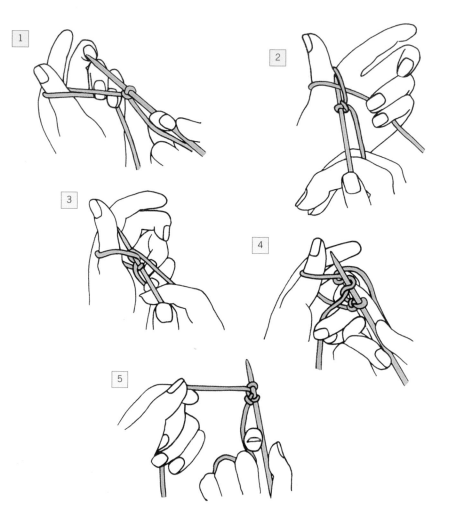

Casting on, Thumb Method

1. Make a slip knot the required length [for a practice piece, make this length about 1m (1yd)] from the end of the yarn. Place the slip knot on a needle and hold the needle in the right hand with the ball end of yarn over your first finger. Hold the other end in the palm of your left hand. Wind the loose end of the yarn around the left thumb from front to back.

2. Insert the needle upward through the yarn on the thumb.

3. Take the yarn over the point of the needle with your right index finger.

4. Draw the yarn back through the loop on the thumb to form a stitch.

5. Remove the yarn from your left thumb and pull the loose end to tighten the stitch. Repeat until the required number of stitches has been cast on.

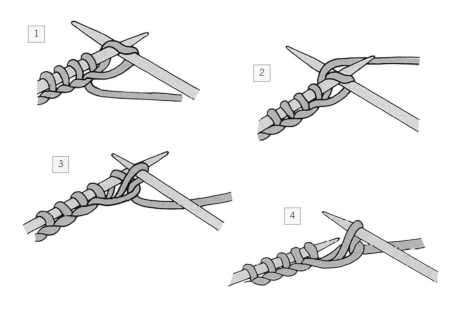

How to Knit

1. Hold the needle with the cast-on stitches in the left hand. With the yarn at the back of the work, insert the right-hand needle as shown through the front of the first stitch on the left-hand needle.

2. Wind the yarn from left to right over the point of the right-hand needle.

3. Draw the yarn back through the stitch, forming a loop on the right-hand needle.

4. Slip the original stitch off the left-hand needle.

How to Purl

1. With the yarn at the front of the work insert the right-hand needle as shown through the front of the first stitch on the left-hand needle.

2. Wind the yarn from right to left over the point of the right-hand needle.

3. Draw a loop through onto the right-hand needle.

4. Slip the original stitch off the left-hand needle. To purl a row, repeat steps 1-4 until all the stitches are transferred to the right-hand needle, then turn the work, transferring the needles, to work the next row.

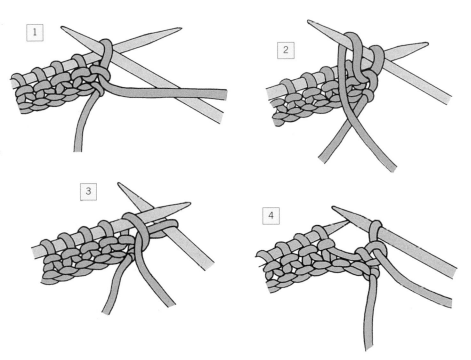

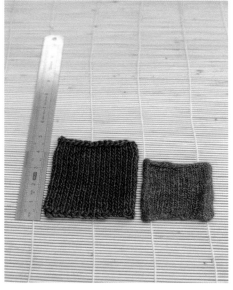

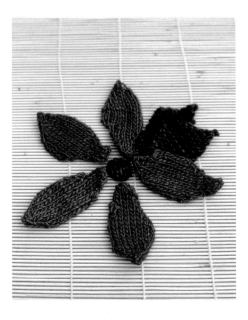

1 Selecting yarn

In general, when selecting yarn for felting, make sure the yarn is at least 70% wool and that it's not a 'superwash' wool (a type of coating applied to wool to prevent it from shrinking). Of course, 100% wools work best, but occasionally, you may come across a mixed fibre yarn that felts really well. It's often a case of trial and error.

2 Shrinkage

The importance of knitting a swatch cannot be overemphasized, no matter how tempting it may be to just dive in and start knitting! Be sure to measure the percentage of shrinkage of your wool by creating a swatch, measuring it, felting it and then measuring again. The type of washing machine, water softness, and washing powder can affect the process quite differently, so monitor your set of variables before you begin.

3 Before felting

Once knitted, your piece may look rough and uneven as it will have been knitted on needles several sizes larger than normal. Don't panic about this. Remember that after felting the object will shrink down to the planned size, and many mistakes will be handily concealed during the felting process. Also, most felted knitting can be cut without fraying so trimming edges will probably be possible.

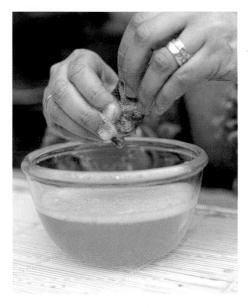

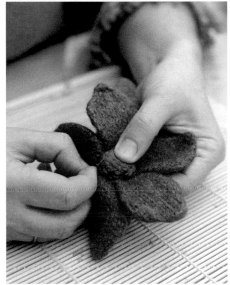

Hand Made

If you are a control freak like me and want to felt your knitting by hand, that is entirely possible too. The benefit is that you can stop when it's done and you don't run the risk of over shrinking. Wet your knitted piece with hot soapy water and start to rub it together. Keep rubbing it with your hands, adding more soap and hot water as required. Start to 'full' it by rubbing it on a bamboo mat or washboard to harden and shrink. Alternating hot and cold water rinses will also speed up the process. Make sure to rinse out all soap thoroughly before drying.

4 Felting

Knitting is most easily felted in the washing machine. Temperatures required to felt vary dramatically depending on the wool used, but as general rule of thumb you will need at least 30°-40°C (85°-105°F) – and more often than not, a 60°C (140°F) wash. Any hotter than this and many wools will lose their colour.

Bear in mind, with a front loading machine you will have to wait for the entire wash cycle to finish before you can check results. If this is the case, pay attention when selecting a temperature – if necessary you can run the item through the cycle again to increase felting and shrinkage.

5 Piecing

In the majority of cases, you would piece things together before you felt, but with some projects it may be better to piece together after felting in order to adjust the pieces into place.

intermediate

★★

flirty flower

Jazz up any outfit with this easy to make flower corsage.
The Karaoke wool is actually 50% silk and 50% wool,
but felts beautifully. Knit first, then felt, piece together
and then feel very pleased with yourself.

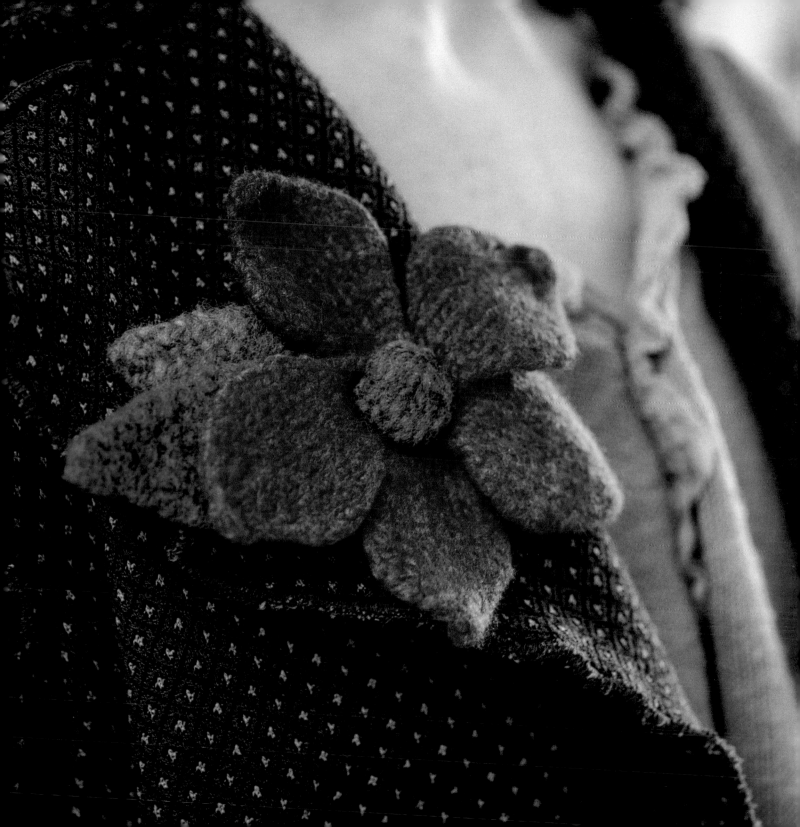

Materials

1 ball of Karaoke by
South West Trading
Company in Wild Cherry,
approx. 101m (110yd)
per 50g ball
(50% wool/50% silk) (A)

1 ball of Kureyon by Noro
in #147, approx. 101m
(110yd) per 50g ball
(100% wool) (B)

1 pair of 6.5mm
(US 10½) needles

A small brooch pin for the
back of the corsage

Needle and thread

Shrinkage rate
Approx. 25-30%

Size
Approx. 13 x 12cm
(5¼ x 4¾in)

Petals (make 5)
With A, cast on 4 sts.
Row 1-4: Work in St st.
Row 5: Knit, inc 1 st each end of row: 6 sts.
Row 6: Purl.
Row 7: Knit, inc 1 st each end of row: 8 sts.
Row 8: Purl.
Row 9: Knit, inc 1 st each end of row: 10 sts.
Row 10: Purl.
Row 11: Knit.
Row 12: Purl.
Row 13: Knit, dec 1 st each end of row: 8 sts.
Row 14: Purl.
Row 15: Knit, dec 1 st each end of row: 6 sts.
Row 16: Purl.
Row 17: Knit 2 tog. 3 times: 3 sts.
Row 18: Purl.
Row 19: Knit 3 tog. Draw wool through loop.
Weave in end.

Bobble (make 1)
With B, cast on 6 sts.
Row 1-6: Work in St st.
Row 7: Cast off knitwise.
Thread end of wool as drawstring round edge,
draw up tight and tie off.

Leaves (make 2)

With B, cast on 4 sts.

Row 1-4: Knit.

Row 5: Knit, inc. 1 st each end of row: 6 sts.

Row 6: Knit.

Row 7: Knit, inc 1 st each end of row: 8 sts.

Row 8-16: Knit.

Row 17: Knit, dec 1 st each end of row: 6 sts.

Row 18: Knit.

Row 19: Knit, dec 1 st. each end of row: 4 sts.

Row 20: Knit.

Row 21: Knit 2 tog. twice.

Row 22: Cast off.

Felt all pieces either by hand or in the machine at 40°C (105°F). Piece together with a needle and thread by sewing flowers together first, then attaching leaves to back and bobble in centre. Finally, attach brooch pin on the back.

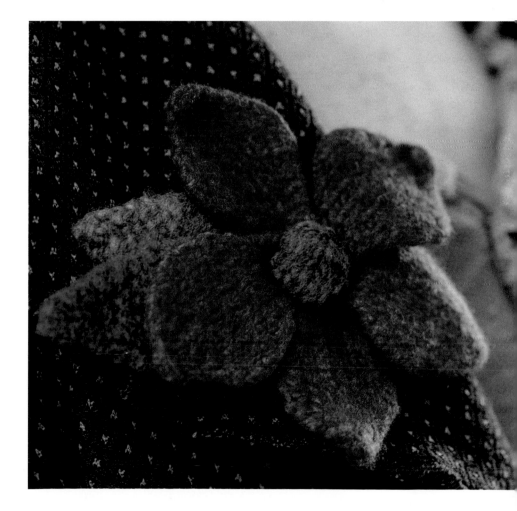

advanced
★★★

icy stripes

This bag is rapidly knitted to gargantuan proportions before felting. However, be quietly confident in the knowledge that Rowan Big Wool shrinks by colossal amounts when felted. The adorable bag you end up with is respectfully average in size, durable and practical – but, of course, retains a chic disposition.

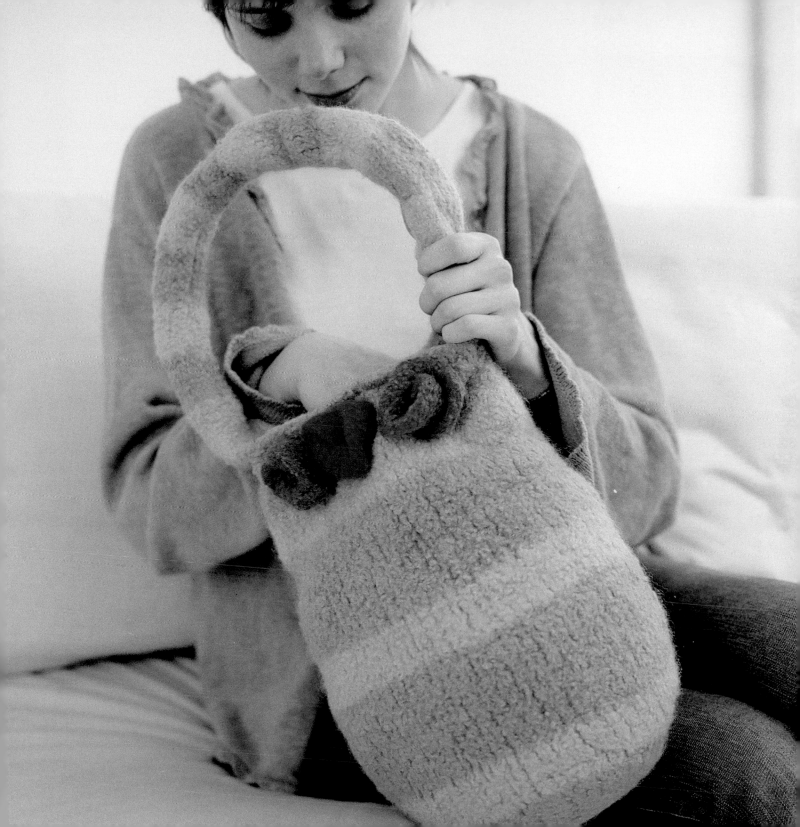

Materials

Big Wool by Rowan,
approx. 80m (87yd) per
100g ball (100% wool):
 3 balls Ice Blue (A)
 2 balls Pistachio (B)
 1 ball Lucky (C)
 1 ball Glamour (D)

1 pair of 15mm (US 19)
needles, 40cm (16in)
long

Needle and thread

Shrinkage rate
Approx. 40%

Size
Excluding handle
36 x 29cm (14½ x 11½in)

Front and back of bag (make 2 in total)

With A, cast on 20 sts.
Row 1: Knit.
Row 2: Purl.
Row 3: Knit, inc 1 st each end of row: 22 sts.
Row 4: Purl.
Row 5: Join in B, knit, inc 1 st each end of row: 24 sts.
Row 6: Purl.
Row 7: Knit, inc 1 st each end of row: 26 sts.
Row 8: Purl.
Row 9: Knit, inc. 1 st each end of row: 28 sts.
Row 10: Purl.
Row 11: Join in A, knit, inc 1 st each end of row: 30 sts.
Row 12: Purl.
Row 13: Knit, inc. 1 st. each end of row: 32 sts
Row 14: Purl.
Row 15: Knit.
Row 16-23: Repeat rows 14 and 15.
Row 24: Purl.
Row 25: Join in B, knit.
Row 26: Purl.
Row 27-30 Repeat rows 25 and 26.
Row 31: Join in A, knit.
Row 32: Purl.
Rows 33-42: Repeat rows 31 and 32.
Row 43: Join in B, knit.
Row 44: Purl.
Row 45-48: Repeat rows 43 and 44.
Row 49: Join in A, knit.
Row 50: Purl.

Row 51: Knit, dec 1 st each end of row: 30 sts.
Row 52: Purl.
Row 53: Knit, dec 1 st. each end of row: 28 sts
Row 54: Purl.
Row 55: Knit dec. 1 st each end of row: 26 sts.
Row 56: Purl.
Row 57: Cast off 26 sts knitwise.
Join sides of bag by stitching together with mattress stitch.

Base of bag

Using Ice Blue cast on 6 sts.
Row 1: Knit.
Row 2: Purl.
Row 3: Knit, inc 1 st each end of row: 8 sts.
Row 4: Purl.
Row 5: Knit, inc 1 st each end of row:10 sts.
Row 6: Purl.
Row 7: Knit, inc 1 st each end of row: 12 sts.
Row 8: Purl, inc 1 st each end of row: 14 sts.
Row 9: Knit.
Row 10: Purl.
Rows 11-12: Repeat rows 9 and 10.
Row 13: Knit, dec 1 st each end of row 12 sts.
Row 14: Purl.
Row 15: Knit, dec 1 st each end of row: 10 sts.
Row 16: Purl.
Row 17: Knit, dec 1 st each end of row: 8 sts.
Row 18: Purl.
Row 19: Knit, dec 1 st each end of row: 6 sts.
Row 20: Purl.
Row 21: Cast off knitwise.
Join base to body of bag with mattress stitch.

Handle

Cast on 16 sts.

Rows 1-6: With A, work in St st.

Rows 7-12: Join B, work in St st.

Repeat rows 1-12 until handle is approx. 80cm (32in) long.

Cast off.

With RS together join long edge, then turn RS outwards.

Sew handles to bag on either side with matching wool before felting.

Felting

Felt the bag in the washing machine at 60°C (140°F). Mould the bag to shape when wet by blocking using a towel and leave to dry. This wool shrinks a lot in the machine, but it might be more difficult to achieve such dramatic results if you are felting by hand.

Flowers (make four)

With C, cast on 15 sts.

Rows 1-18: Work in St st.

Cast off.

Repeat once again with C, and twice with D.

When felted, each rectangle can be cut diagonally to form two triangles. To make the flowers, coil each triangle from one end, stitch into place, fold down the top corner of the triangle behind the coil and stitch into place again. Attach to the bag in alternating colours – I have put three flowers on each side.

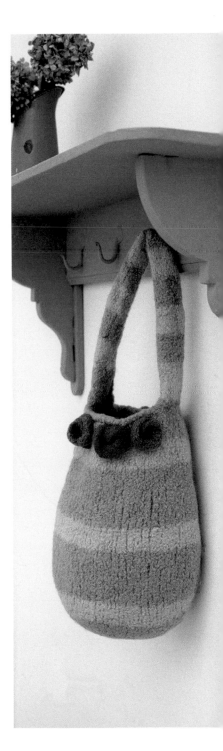

intermediate
★★

carousel cushion

The inspiration for this project came totally and utterly from an amazing hand-dyed, hand-spun yarn – and I want your inspiration to be the same too! Be brave, grab the vibrant colourful yarn of your choice, and start to crochet round and round and round...

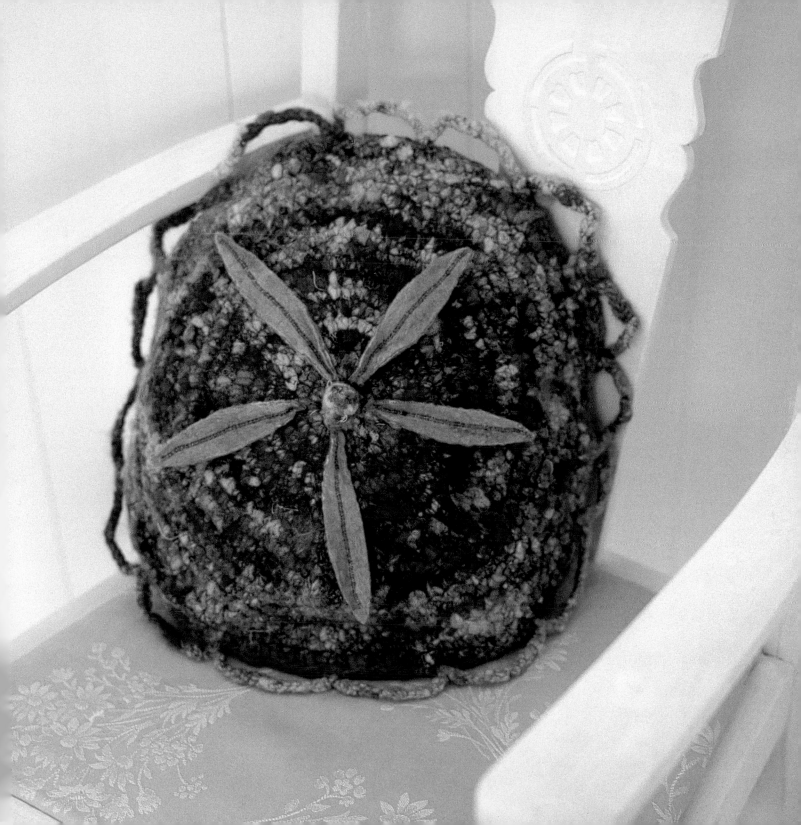

Materials

1 ball of variegated yarn, approx. 90m (100yd), (at least 90% wool)

A large crochet hook 5-6mm (US H/8-J/10) depending on yarn

A piece of cotton velvet or other material for the back of the cushion

5 handmade felt leaf shapes made from flat felt (see pages 22-25)

Contrast hand or machine embroidery thread

A cushion pad approx. 40cm (16in) in diameter

Needle and thread

Shrinkage rate
Approx. 10%

Size
34 x 42cm (13½ x 17in)

You will need to know how to chain (ch), slip stitch and double crochet (dc) – for this project and that's all!

The object of the exercise is to create a round circle measuring about 42-45cm (17-18in) in diameter, which is as flat as possible. Don't worry if it isn't perfect or completely flat, because the felting process will hide most mistakes or puckers.

Your yarn will be different to the one I used so my instructions may make your piece seem too flared. If so, decrease the number of stitches as you go round by missing every or 4th or 5th stitch until it is flatter. If your piece seems too cup-like, increase the number of stitches every 4th or 5th stitch by doing two stitches in one, until it flattens out again.

My yarn only shrank by about 10% since I hand-felted it – you should create a swatch to felt first to measure your yarn shrinkage and adjust sizes accordingly.

1 Ch 4, join into a ring with slip stitch.

2 8 dc in the ring and then 2 dc in each dc: 16 sts.

3 *1 dc in 1st stitch, then 2 in following stitch* repeat all the way around: 24 sts.

4 1dc in each dc.

5 *1dc in 1st 2 sts, then 2dc in third st* repeat all the way around.

6 Dc in each st, increasing 1 dc every 5 sts.

7 1 dc in each st for next 5 rows.

8 Keep going round for about another 10 rows using double crochet, increasing or decreasing as necessary, until the piece measures about 45cm (18in) in diameter.

9 Slip stitch to finish. Dc and ch 12 in approx. every 7th stitch all the way around to form the scalloped petal edge. Slip stitch to finish and trim thread.

10 Freeform crochet a bobble for the centre or chain 4 and join with slip stitch. Now dc into the front of each stitch and go round until it is bobble shaped. Finish and trim.

11 Either machine or hand felt the cushion front and bobble (see pages 78-79), depending on your yarn and how in control you want to be! If it is a hand-dyed yarn like this one, take care with the temperature and start by felting at no more than 30°C (85°F). It is important not to lose colour from the yarn – you can always repeat the process again if it has not felted sufficiently. Once you are happy, flatten it by pressing while damp on a wool setting.

12 Leave to dry then attach the bobble with some matching yarn or thread. Machine or hand embroider on

the leaves with some contrasting embroidery thread if desired and then attach in the same way.

13 To make the back, cut two semi-circles of cotton velvet the same size as the cushion front, and add a 2.5cm (1in) seam allowance around curved edge and a 5cm (2in) overlap along straight edge. With WS together, place the semi-circles against the felted front piece, making sure to overlap the straight edges. Fold under a seam around the curved outside edge, pin and hand-sew together around the edge. Insert a round 40cm (16in) cushion pad inside the flap.

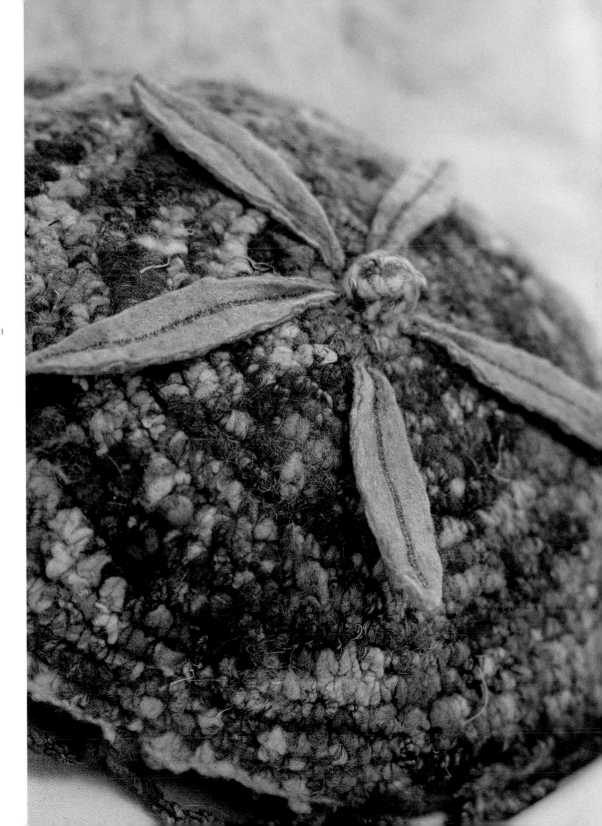

beginner

★

patchwork perfect

Here's a great project to recycle old sweaters from your wardrobe or a local charity shop and give them a new lease of life by intentionally shrinking and felting them in the washing machine. Once felted, cut them into squares and create a shabby chic accessory to wear when temperatures drop!

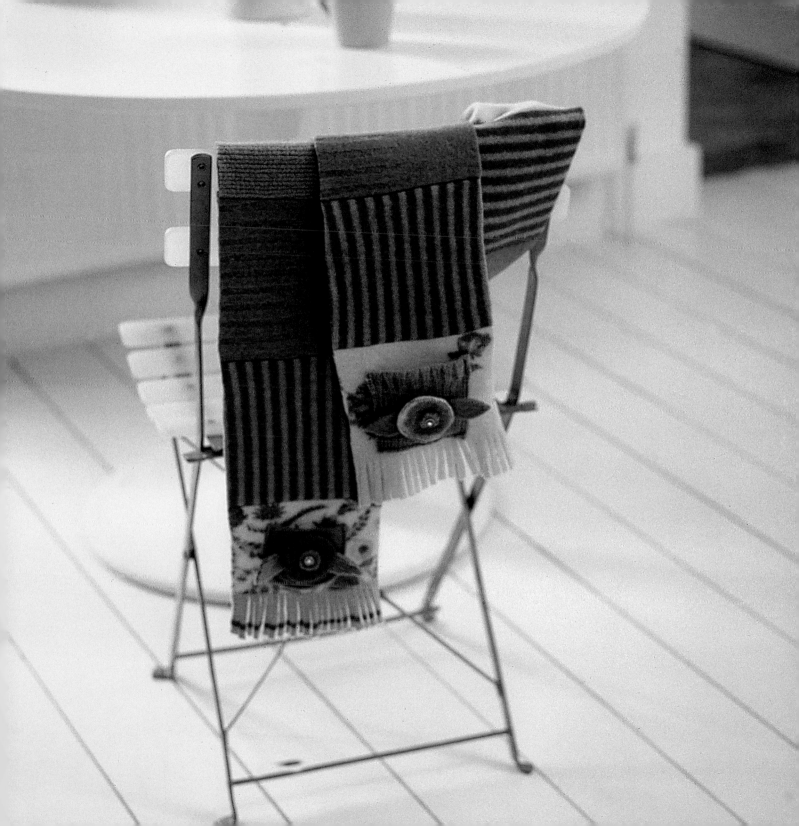

Materials

Several wool sweaters in coordinated colours made from at least 80% wool (see notes, right)

Needle and thread

Coordinating embroidery threads (optional)

A couple of buttons or beads (optional)

Size
Approx. 17.5 x 210cm (7 x 84in)

1 Felt the sweaters in the washing machine, adding an old pair of jeans to create friction. Repeat if necessary until sweaters are completely felted. Allow to dry.

2 Decide how long you want your scarf to be, and then cut sufficient 17.5 x 20cm (7 x 8in) rectangles from the sweaters. The longer dimension is to allow for the seams at each end of the rectangle. Don't just cut from the centre of the body – think about opening up the arm seams too and maybe include cuff and hem details.

3 Lay the rectangles out on a table and move the pieces around until you are happy with the colour combinations. Try alternating colours and tones to provide contrasts.

4 Pin the rectangles together to make the scarf and tack together. Machine- or hand-sew each piece together to form a long scarf. Press the reverse if required, to open out the seams.

5 Cut two pieces to make a small pocket at either end of the scarf. Then cut two 5cm (2in) diameter circles in bright colours and two 2.5cm (1in) in diameter in contrast colours to make two flowers. Cut a couple of leaves for each flower.

6 Centre the smaller circle over the larger to form the flowers, then stitch the leaves in the centre of each pocket with the flower on top. Decorate the flowers with thread and buttons or small beads if you so desire. Sew the pockets onto the scarf, taking care to leave the top edge of each pocket open!

A few words about which wool sweaters to choose. A good indication of suitability for this project is a combination of the words '100% Wool' and 'Hand Wash Only'. This means the item will probably shrink and felt in the machine – which is exactly what we want!

Steer clear of wool sweaters labelled that they can be safely washed at 40°C (104°F) – these are more than likely made from 'Superwash' wool and won't shrink or felt, as the wool fibres have been coated to protect them. Likewise, don't use any items with synthetic fibres, or a mixture with less than 80% wool. Anything such as regular wool, alpaca, mohair, angora, lambswool or cashmere would be ideal. I would suggest washing suitable knitting at between 50-60°C (120-140°F) to make sure it is well felted. The outcome is similar to boiled wool, although a boil wash is not recommended as it often results in colour loss. Once cut, your felted sweaters will no longer unravel or fray.

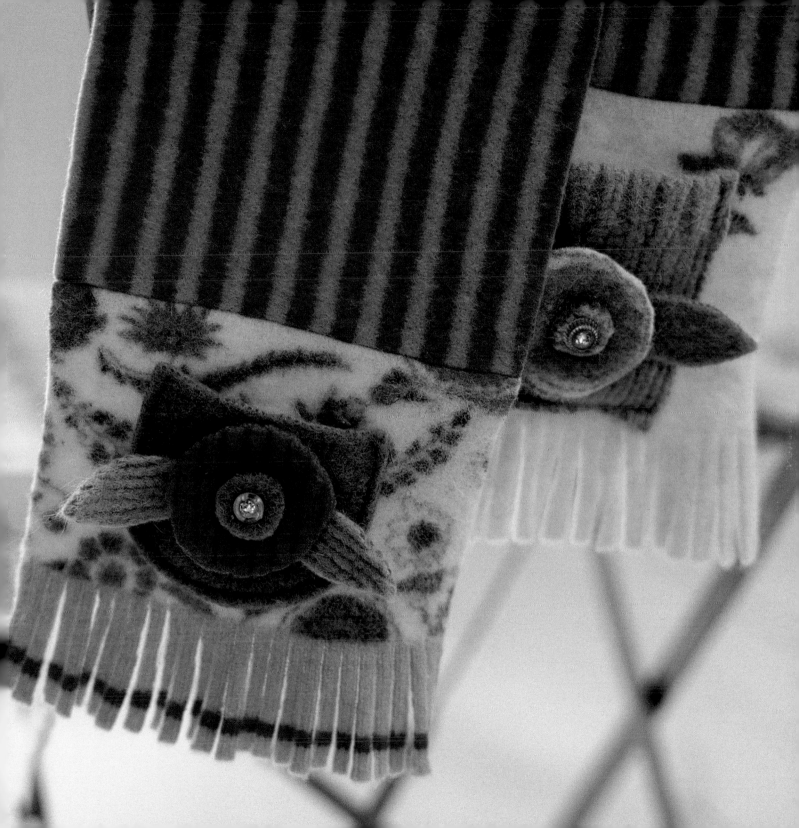

intermediate

I ♥ You

Some of us will have fond memories of our first baby blanket, often still held with the highest regard well into adulthood. This wee knitted coverlet is felted for warmth and endurance, is stimulatingly colourful and is fashionably frilly. I ♥ it!

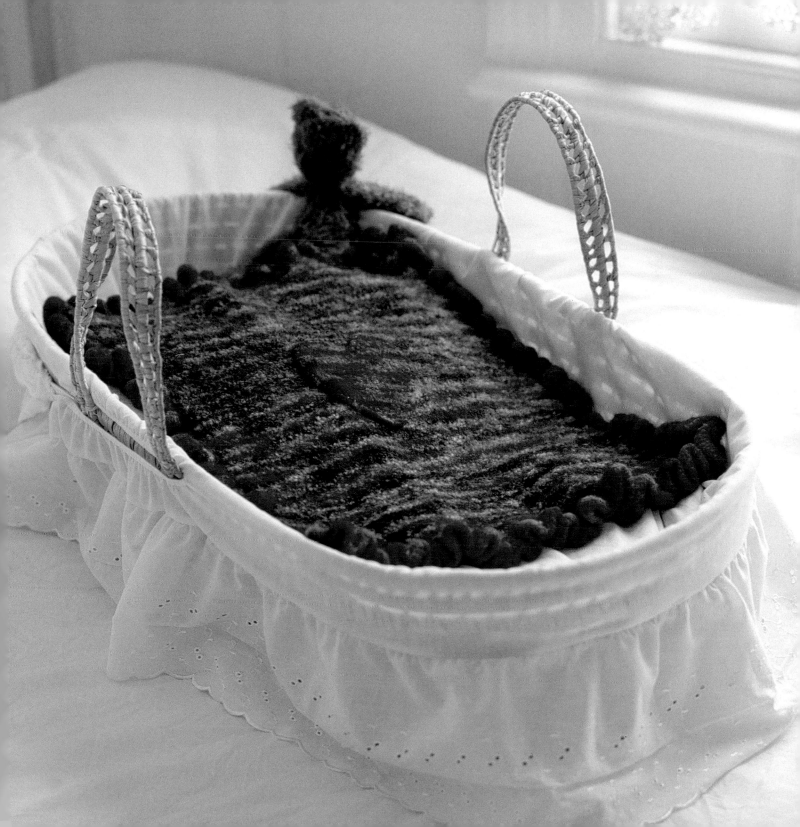

Materials

Skye by Colinette, approx. 138m (142yd) per 100g, (100% wool):

 2 hanks in Jamboree (A)
 2 hanks in Fire (B)

1 pair of very long 8mm (US 11) needles

Needle and thread

Shrinkage rate

Approx. 25%

Size

Approx. 54 x 41cm (21½ x 16½in)

Blanket

With A, cast on 71 sts.
Knit in St st until the work measures approximately 82.5cm (33in) in length.
Cast off knitwise.

Edging

Short ends
Pick up 71 sts across one short end.
Row 1: With B, knit.
Row 2: Purl.
Row 3: Knit into front and back of each stitch: 142 sts.
Row 4: Purl.
Row 5: Knit into front and back of each stitch: 284 sts.
Row 6: Purl.
Row 7: Cast off knitwise.
Repeat for second short end.

Long ends
Pick up 92 sts across one long end.
Row 1: With B, knit.
Row 2: Purl.
Row 3: Knit into back and front of each stitch: 184 sts.
Row 4: Purl.
Row 5: Knit into front and back of each stitch: 368 sts.
Row 6: Purl.
Row 7: Cast off knitwise.
Repeat for 2nd long side.

Join frills at each corner of blanket and darn in ends of wool.

Heart motif

With B, cast on 6 sts.
Row 1: Knit.
Row 2: Purl.
Row 3: Knit, inc 1 st at each end of row: 8 sts.
Row 4: Purl.
Row 5: Knit, inc 1 st at each end of row: 10 sts.
Row 6: Purl.
Row 7: Knit, inc 1 st at each end of row: 12 sts.
Row 8: Purl.
Row 9: Knit, inc 1 st at each end of row: 14 sts.
Row 10: Purl.
Row 11: Knit, inc 1 st at each end of row: 16 sts.
Row 12: Purl
Row 13: Knit, inc 1 st at each end of row: 18 sts.
Row 14: Purl.
Rows 15-24: Work in St st.
Row 25: Knit, dec 1 st each end: 16 sts.
Row 26: Working on first 8 sts of the row only, P6, P2 tog. Turn.
Row 27: K7.
Row 28: P2tog, P3, P2 tog. Turn.
Row 29: K2tog, K3.
Row 30: Cast off 4 sts knitwise. Join wool to last 8 sts.
Row 31: P2tog, purl to end: 7 sts.
Row 32: Knit.
Row 33: P2tog, P3, P2tog: 5 sts.
Row 34: K2tog, knit to end: 4 sts.
Row 35: Cast off remaining 4 sts.

Felt the blanket and the heart separately in the washing machine on a 30ºC (85ºF) wash cycle. This wool is hand-dyed and will lose colour if it is washed any hotter. Alternatively, felt by hand.

Once dry, press with the iron on a wool setting to flatten and attach the heart by hand, using running stitch or machine stitch.

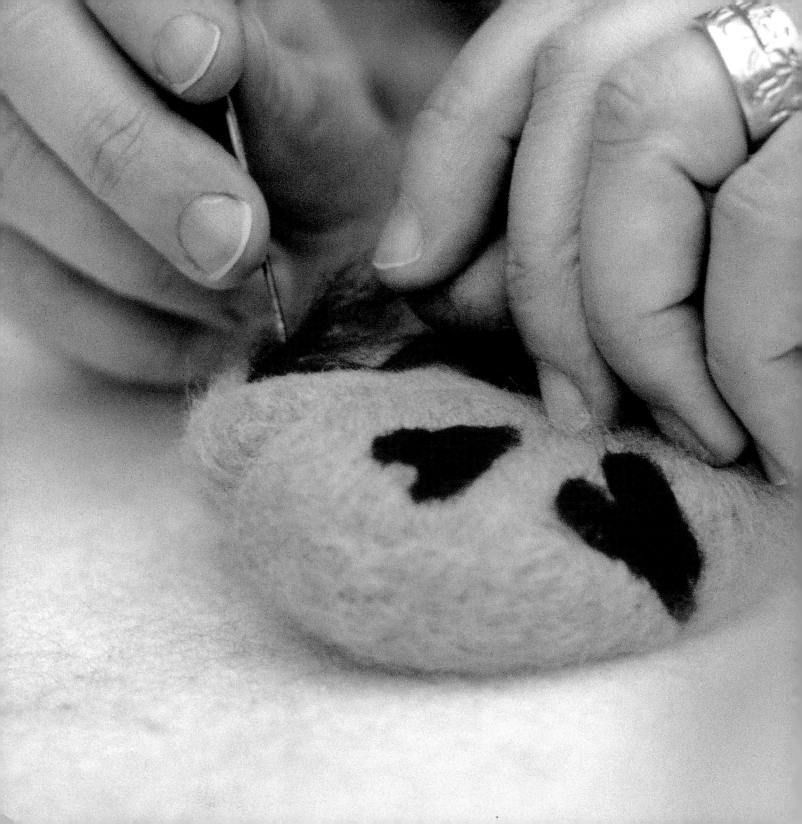

needle felting

Needle felting offers numerous benefits: it lends itself to very different types of sculptural projects; it combines wonderfully with wet felting to produce interesting effects; and last but not least, needle felting requires no water, soap or rubbing. Using extremely sharp, barbed needles, fibres are pushed up and down until they start to tangle and bond together. By repeatedly stabbing the needles in and out of the fleece, 3-d shapes can be formed and very fine detail can be added, which is easier to achieve than with other felting techniques such as wet felting.

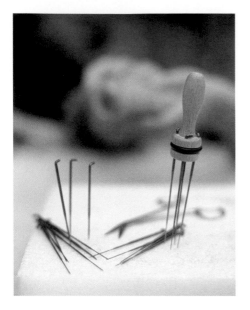
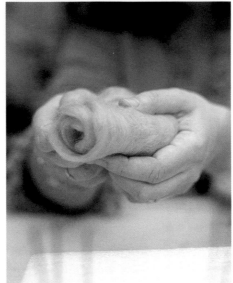
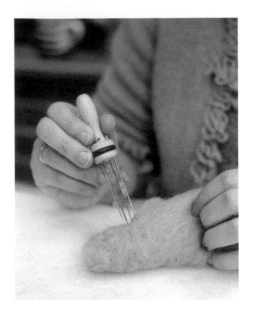

1 Equipment

When dry felting with needles, try always to work on a dense polystyrene block to protect your work surface and keep your felting needles together to prevent accidents! Felting needles are available in a range of sizes and gauges, which lend themselves to different applications. Bigger needles are used to mould and shape, whilst finer needles are used to apply detail and pattern. It is useful to have a selection.

2 Moulding wool fleece

I prefer to work freeform when needle felting, using scraps of old fleece as my core and bunching it up to mould it into the required shape. However, if you're new to the needle felting process, I strongly advise you to work your first few projects using a foam core or shape and wrapping the fleece around it. Not only is it easier to create your required shape, it's much safer!

3 Using felting needles

When using felting needles over large areas, a multi-needle tool with four or six needles helps speed up the process. Use larger felting needles at the start of the process. As you continue to stab, the barbs on the needles will tangle the wool fibres together and create a dense and hardened felted mass. Remember to work safely with the needles pointing away from your fingers, and make sure you keep the needles as upright and perpendicular as possible as you stab the fleece to prevent needle breakage.

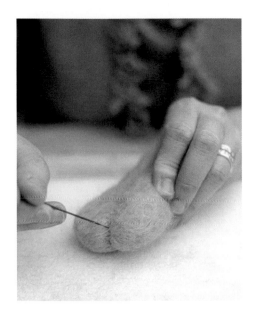

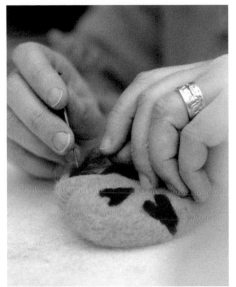

Shrinking Fibres

Remember that your needle felt projects will shrink down just as your wet felt does even though no heat or soap is used. The constant stabbing of the fibres compacts the fleece dramatically.

4 Shaping

After creating the general shape, start to refine it using one needle. Continuously rotate the piece to ensure evenness around the shape. To create an indentation, repeatedly stab one area of the felt using a large single needle. This is a great way to create shapes such as stars, which may require indentation on several sides. Remember, as a beginner, do not rush the process and work at a slow and steady pace to avoid puncturing your skin accidentally.

5 Attaching motifs

By using a finer gauge needle, decorative patterns can be added without distorting the shape of your project. Take wispy pieces of fleece and attach them by stabbing them into the main piece until they mesh.

advanced
★★★

tooth fairy cushion

Fairies all over the world are thanking their lucky stars for this Tooth Fairy Cushion which is designed to hang on the door knob or bedpost and therefore minimise sleep disturbance! Complete with an integral tooth/money pocket, I'm sure it will delight many a small person – and many a tooth fairy.

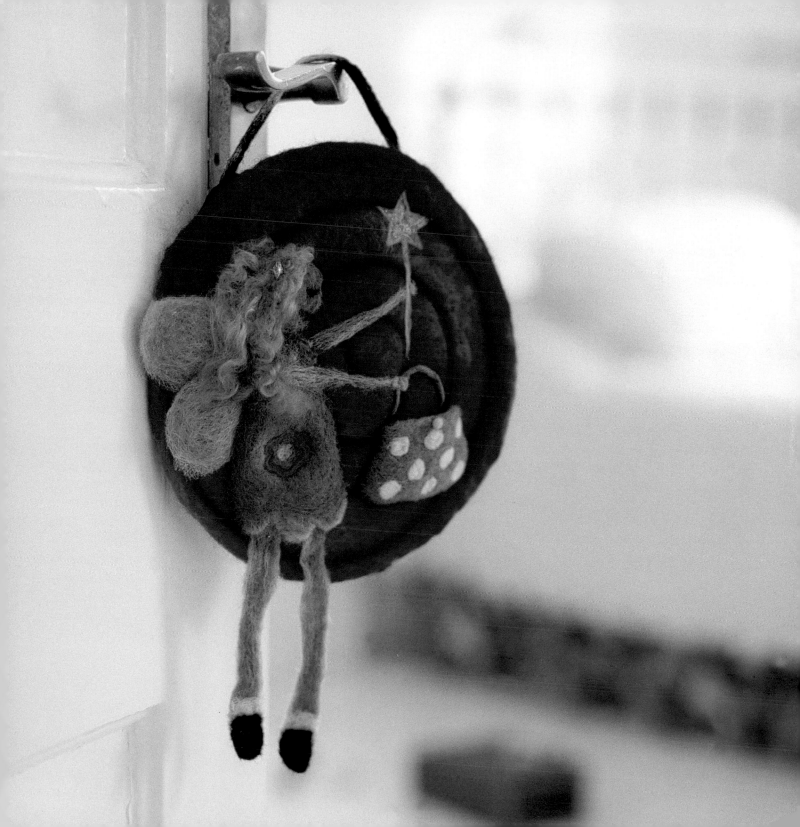

Materials

Merino wool tops:
 50g of red/orange mix

 Small amount of blue,
 pink, beige, yellow,
 lilac, white, orange,
 black and burgundy

Small quantity of space-
dyed curly kid mohair

Length of felt or some
ribbon

A crystal bead

Needle and thread

Heat-bondable Angelina
glitter fibre (optional)

Felting needles

Size

Approx. 18cm (7in) in
diameter.

1 Bunch up some red/orange fleece into a round pouch shape, allowing for a slight reduction in size once the wool is compacted together with the needles. Shape with a multi-needle felt tool and large needles. Keep stabbing away for between 30-40 minutes to establish your round shape. Keep turning the shape to make sure it remains even and add some different shades of the same colour as you work to add depth.

2 Once the shape is defined, use one or two needles at a time to refine it. Take some burgundy wool and lay out the spiral shape radiating out from the centre. Attach it little by little using the felting needle.

3 Using the larger needles in the multi-needle tool, and working on a piece of dense foam, make a flat piece of lilac and blue needle felt measuring about 7.5 x 5cm (3 x 2in), then cut out the fairy dress with its scalloped edge. Using a finer gauge needle for detailed decorative work, add a small flower design in the middle of the dress in orange and yellow fleece. Make a slightly smaller piece of flat blue needle felt with white spots and cut the bag shape out of it.

4 Again working directly onto dense foam, make the legs by taking small amounts of pink and beige fleece and combining them together into two long strips. Once they are needle felted, trim using some small scissors if necessary. Add a little white sock and black shoe at the end of each leg. Make two similar but smaller beige and pink strips for the arms.

5 Make the wings next. Shape and needle felt a little pink fleece into two wing shapes, stabbing in some heat-bondable Angelina fibre as well, if you have some. If you use the Angelina fibre, place the wings between two sheets of parchment paper and press gently with a warm iron to bond fibres to the fleece and stiffen.

6 To assemble the cushion, first place the legs and then the wings. Needle felt everything into position on the round shape, using the larger needle. Pay particular attention to the edges of the dress, but leave the base of the dress open. Likewise, needle felt the edges of the bag only. Do not needle felt the middle of the bag onto the pouch as this is your tooth/money receptacle, but make sure the edges are well attached and that there are no gaps.

7 Add some curly mohair for the hair, felting in position with the needle in the same way. Then add small eye and mouth details. Make a wand with a little yellow fleece, and needle felt some Angelina fibre into the centre of the star. Sew a little crystal bead into fairy's hair – fairies need to accessorize too you know!

8 Finally, make a tiny handle for the handbag in blue, and a tiny fairy button for the handbag in yellow, and attach firmly by needle felting with the fine needle.

9 Finish by sewing a felt or ribbon hanger to the top of the pouch on the reverse side.

complete feltmaking 107

beginner

★

heart to hearts

Featuring an endearing all over pattern, this heart felt
design makes sewing even more fun! The density of
the cushion has a springiness that's ideal for pins.
A colourful gingham-patterned ribbon tie can be used
to tie the pin cushion around your wrist.

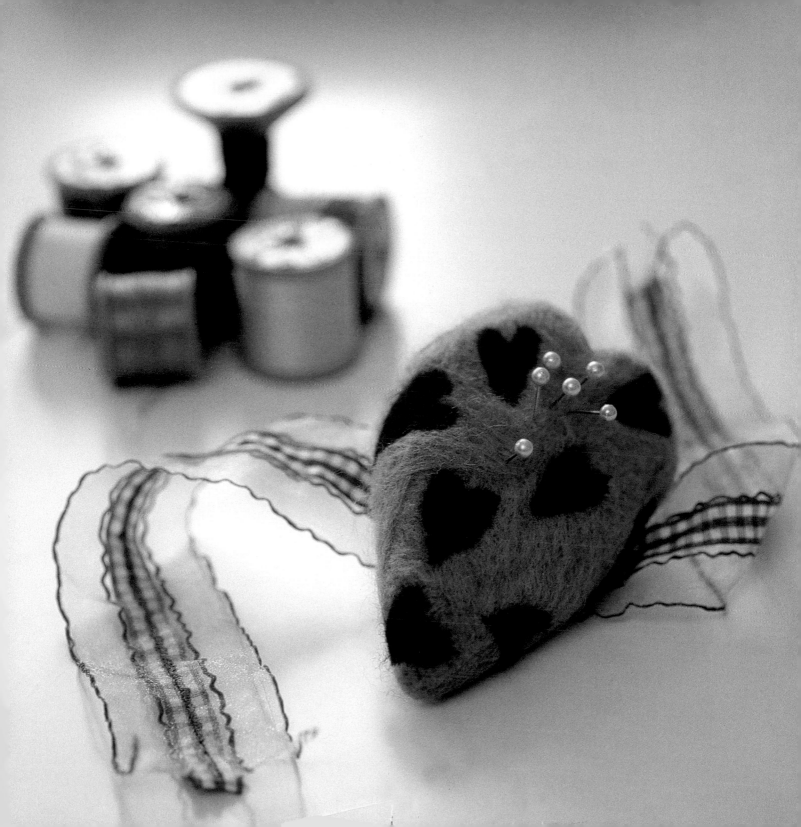

Materials

Merino wool tops:
 25g of candy pink

 Small amount of cherry
 red

Core foam shape

35cm (14in) length of
ribbon

Hook-and-loop tape or
similar (optional)

Needle and thread

Selection of felting
needles

Size

Approx. 10 x 7.5cm
(4 x 3in)

1 If you are using a core foam shape, start to wrap with pink fleece. Otherwise take a dense bunch of any spare fleece and form a rough heart shape with it. Continue to build up layers of pink fleece, using the multi-needle tool with larger needles to form the base shape. Keep jabbing away for at least ten minutes – and remember that this shape will shrink down in size just like wet felting. The more you needle felt, the smaller it gets.

2 Refine the shape and make the indentation at the top of the heart by repeatedly stabbing with a single needle. Mould the bottom of the heart to a point and keep turning it around to make sure it is even. Spend at least half an hour making sure the shape is right before you move on.

3 Once you are happy with the core shape, switch to a finer gauge needle. Taking very small amounts of red fleece, work randomly-spaced hearts over the pin cushion.

4 Measure a length of ribbon to go around your wrist – or wherever you want to tie it – and then attach a square of hook-and-loop tape (or similar) at each end, if required. Alternatively you can make the ribbon longer and just tie it. Sew the ribbon firmly onto the back of the pin cushion.

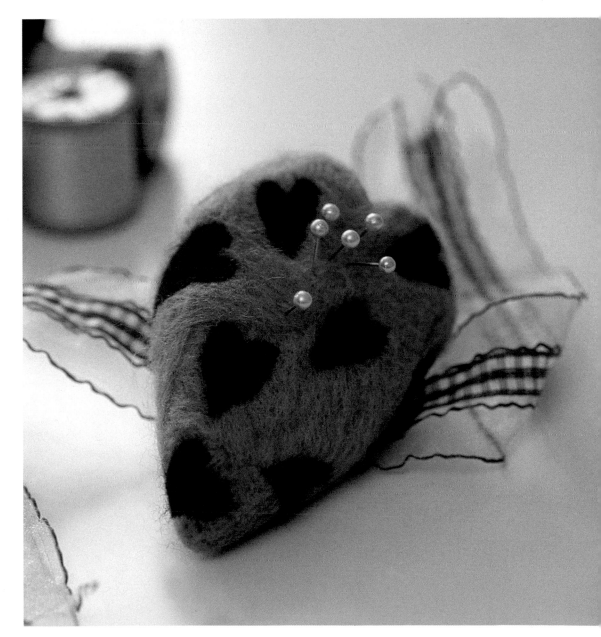

intermediate
★★

under cover

Store your favourite photographs in an album with a felted cover. Instead of using the word 'photos' you may want to have a name, or maybe adapt this design for a wedding album or scrapbook. For this project it's best to start with a large piece of flat felt (see pages 22-25). I started with a piece of white Merino and 'space-dyed' it with some wool dyes. Alternatively, just make a piece of flat felt from coloured merino wool tops, perhaps mixing several colours together to achieve your desired background colour – in this instance a dusty blue with areas of purple and green.

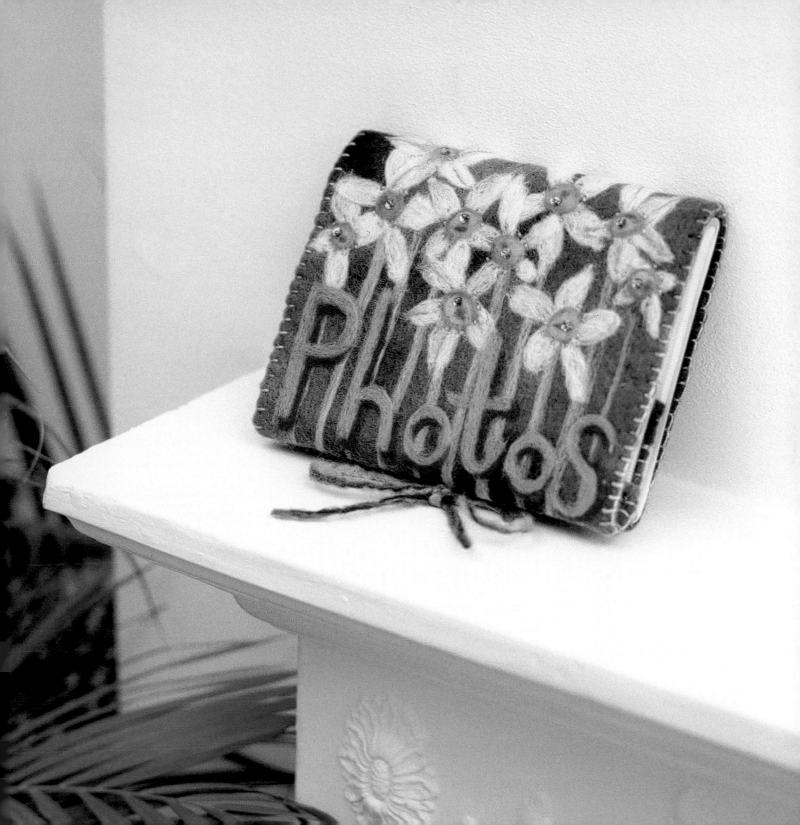

Materials

Large piece of dark colour flat felt, the width of your album and 12.5cm (5in) longer than front plus back, including spine

Merino wool tops:
 Small amounts of white, yellow, orange, lime, dark green, olive green, candy pink, dark pink

Fine gauge felting needles

Blue embroidery thread

Sequins, seed beads

A beading needle

Contrast thread

Felt or ribbon for tie

Needle and thread or fabric glue

Size

14 x 17cm (5½ x 6¾in)

1 When making the flat felt before you start, measure the book or album or album you want to cover, allowing for the spine and a flap on either end, then increase the size by at least 20% all round. You can always cut it down further, but you can't make it larger, so overestimate!

2 When the flat felt is fully dry start needle felting your design onto it, working with some dense foam underneath. As all the needle felting will be decorative rather than sculptural, use fine gauge needles. Mark out the area for the front of the album with some pins so you don't needle felt in the wrong place. Start with the flower stalks. Lay strips of pale green fleece down and needle felt into position. Prepare small wisps of white for the flowers by folding the fleece into petal shapes. Needle felt about five petals onto each stem – randomly is fine, the flowers don't need to look uniform. Some can overlap each other.

3 Add flower centres and details with small amounts of yellow and green and tiny spots of orange in the centre.

4 For the lettering, lay out the letters of your word with some thread or string just sitting on top of the felt – this really helps with spacing. Lay down the letters in the light pink wool first – if you are using different colours, check the lettering contrasts well with the background so it is legible.

5 Before adding the drop shadow (optional) to the letters, sketch it out on paper to see where the shadows should fall. Use small pieces of darker pink for the shadow, attaching the fleece with the needle as you work round each letter. Use small scissors to snip off any excess.

6 As a final touch, embroider around each flower centre with a simple running stitch, using pale blue embroidery thread. Finish with a sequin and seed bead in the centre of each flower.

7 Work blanket stitch down either side of the cover using a contrasting embroidery thread. Then place the cover on the book or album and either glue or oversew the end flaps in place. Sew or glue a thin felt or fabric ribbon onto both end flaps and tie in a bow.

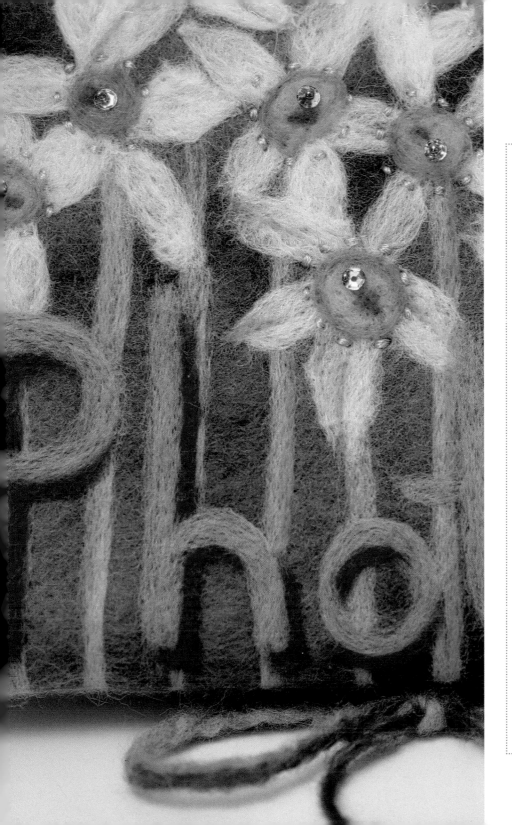

Dye-namite!

Although wool tops are available in a spectrum of colours, it is fun to experiment with dyeing your own fleece – either before or after you have made it into felt – to achieve some subtle and interesting variations in colour.

Use an all-in-one acid dye powder suitable for wool, in several contrasting colours. A little goes a long way, so you don't need much. Here is an easy method for space-dyeing wool felt:

1 Lay out the felt to be dyed in a thick heatproof bowl or tray. Keep one specially for dyeing and do not use for food afterwards because most dyes are poisonous.

2 Barely cover the felt with boiling water, then sprinkle small amounts of dye powder on top, using two or three colours across different areas. Leave for half an hour to an hour, depending on the depth of colour required. Rinse thoroughly and leave to dry. A small amount of shrinkage may occur, depending on how fulled the felt is.

intermediate
★★

jingle bell

Trap a small bell in the core of this toy and a playful
kitten will spend hours upon hours in amusement.
Designed to stop just before it rolls under the sofa, this
needle felted ball has small protrusions to give optimum
rolling distances. You can adapt the design for fantastic
jingling christmas ornaments, juggling balls, and so on...

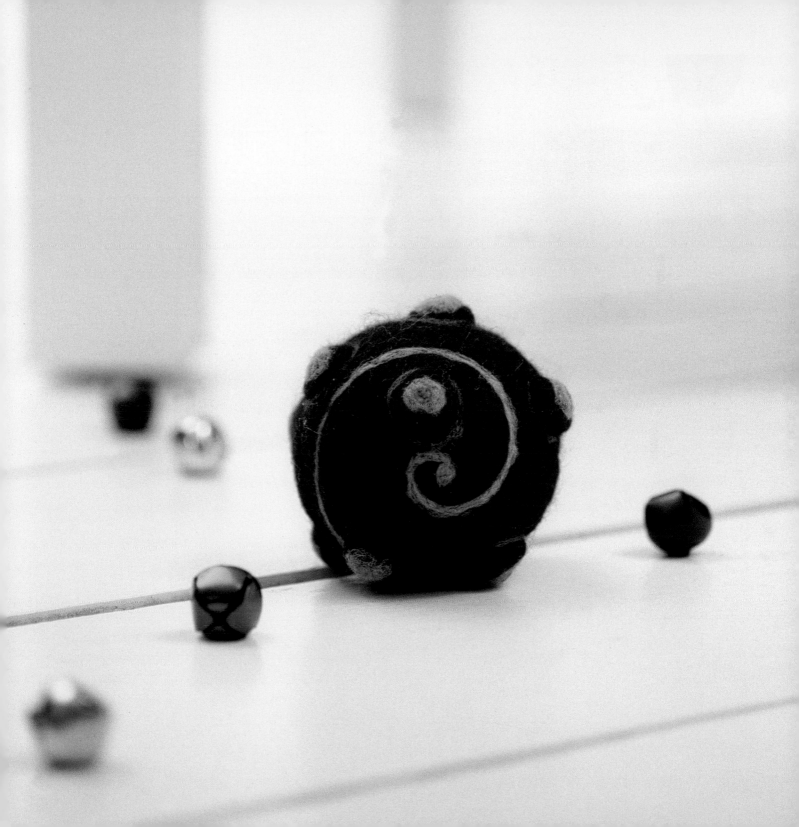

Materials

Merino wool tops:
 25g of dark red

 Small amounts of pink,
 green, yellow and blue

Selection of felting needles

A small round bell

Size

Approx. 7.5cm (3in) in diameter

1 Start by wrapping the bell in a wad of red fleece. Start wrapping further fleece around this to form a rounded ball shape – it needs to be about 40% larger than you want the final ball to be, as the needle felting compacts the fleece down considerably.

2 Start stabbing using the larger needles in the multi-needle tool, while turning the ball continuously to make sure it remains round. Really persevere here – it can take quite a while to get the shape to compact evenly and look right all round. Add more fleece as necessary, until the ball ends up about the size of a tennis ball.

3 Attach a thin yellow spiral of fleece using a finer felting needle, radiating it out from one end and going around the ball until it finishes up at the other end.

4 Using the larger needles again, start to needle felt some bobbles. Bunch up small amounts of red fleece and needle felt them to compact them into a bobble shape. Add the bobbles randomly onto the main ball one by one. Keep reshaping as necessary.

5 Using a finer needle, add
some decoration using
blue fleece around each
bobble, and pink and green
fleece spots on top of each
bobble.

6 Call the cat and test the
ball out.

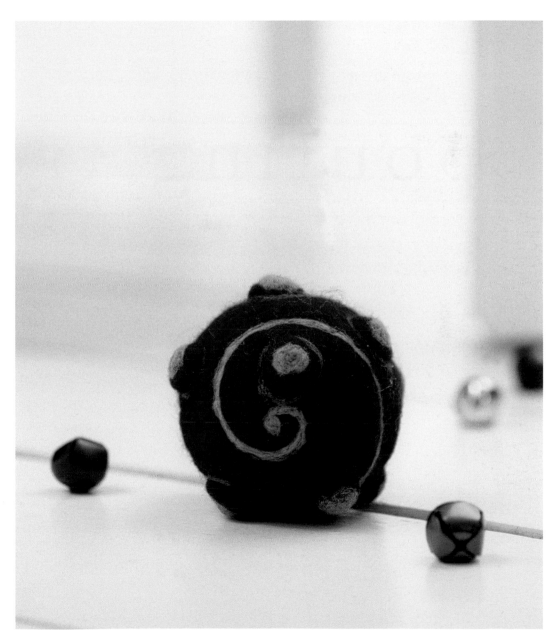

advanced
★★★

pouting trout

Inspired by the salty sea air, I made these fantasy felt fish while watching the boats bob off the coast of England. (I don't advise needle felting on a rocking boat!!) Hang these colourful fish from a piece of dried driftwood to keep to the seaside theme.

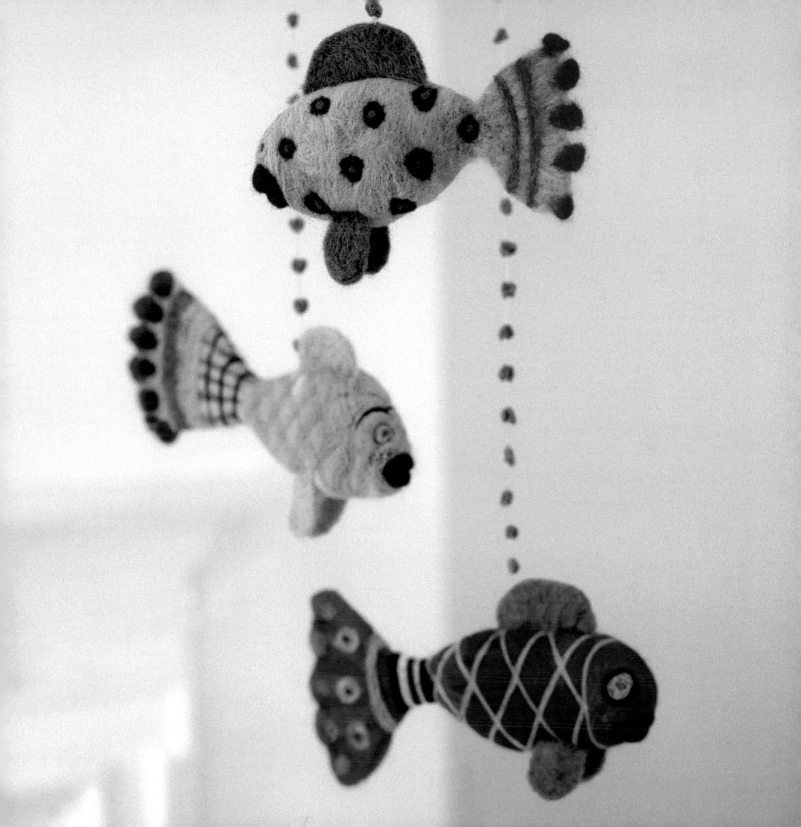

Materials

Merino wool tops:
30g of pale lime, orange and pale blue

Small amounts of purple, dark red, lime, burgundy, olive green, turquoise, pale turquoise, black, white, yellow, pale pink, coral, magenta and cerise

Selection of felting needles

3 foam fish shapes (optional)

Fancy braid or ribbon

Piece of driftwood

Needle and thread

Size

Each fish approx. 20cm (8in) long.

1 Start with a large felting needle. For the orange fish, begin by making a basic oval shape for the body. Remember that fibres condense and mat together as you are needle felting, so the shape will shrink just as in other forms of feltmaking. Spend some time on the body, constantly turning and refining the shape. Use several different shades of the same colour over the top of one another to add depth and shading.

2 Next, working directly onto dense foam, make a flat fish-tail shape with the same colour as the body. Trim if required and attach this to the main body of the fish. Fan the tail end slightly.

3 Now make the fins. Make two smaller fin shapes and one larger and longer one for the top fin. Trim to shape with some small scissors if necessary. Pin the fins into position to get them looking correct before needle felting onto the fish.

4 Using a fine needle, attach the pattern detail using the picture on page 121 as reference. First criss-cross the pale blue lines on the body, then wrap and attach black and white stripes at the top of the tail. Make pink stripes fan down the tail, then add the coloured spots. Finally add two eyes in blue with a small pink centre and outline in burgundy.

5 To make the lips for the fish use larger needles to make an oval shape in dark red fleece. Once you have the right shape attach it at the front of the fish by needling around the edges. When it is fixed start to push the needle in more along the centre line and indent the felt to form two lips. Keep stabbing until they are firmly in place and well outlined.

6 Repeat for the other two fish, using different colours and patterns – use the picture on page 121 as reference or just use your imagination!

7 With a needle and thread, stitch a piece of cord or ribbon to the top fin of each fish. Make each hanging cord a slightly different length so that the fish float at different heights. Attach the cords to convenient points on the driftwood or similar, then bring all three pieces to the centre above and tie off. Hang the mobile from a small hook fixed in the ceiling.

advanced techniques

In this chapter, I wanted to share some of the other exciting
feltmaking techniques I have discovered over the years. Cobweb
felting results in a marvellous gossamer-like fabric and provides
plenty of scope for artistic interpretation and design, while nuno
felt is a way of incorporating the feltmaking process into a piece
of sheer fabric. Felting with lasts and objects can be a terrific
way of moulding wool felt, as you will see with the slippers and
bowl projects that are fulled in the washing machine. Finally,
working in a painterly style, lots of techniques come together in
a hybrid felt wall hanging.

advanced
★★★

cobweb cool

The ethereal and gossamer-like effect of this sublime scarf is achieved through a process known as cobweb felting. By layering tiny amounts of wool fleece, a very delicate sheer felt can be created, rather like a very fine lace. Using too much fleece will simply result in a thicker felt, which will bear no relation to a cobweb!

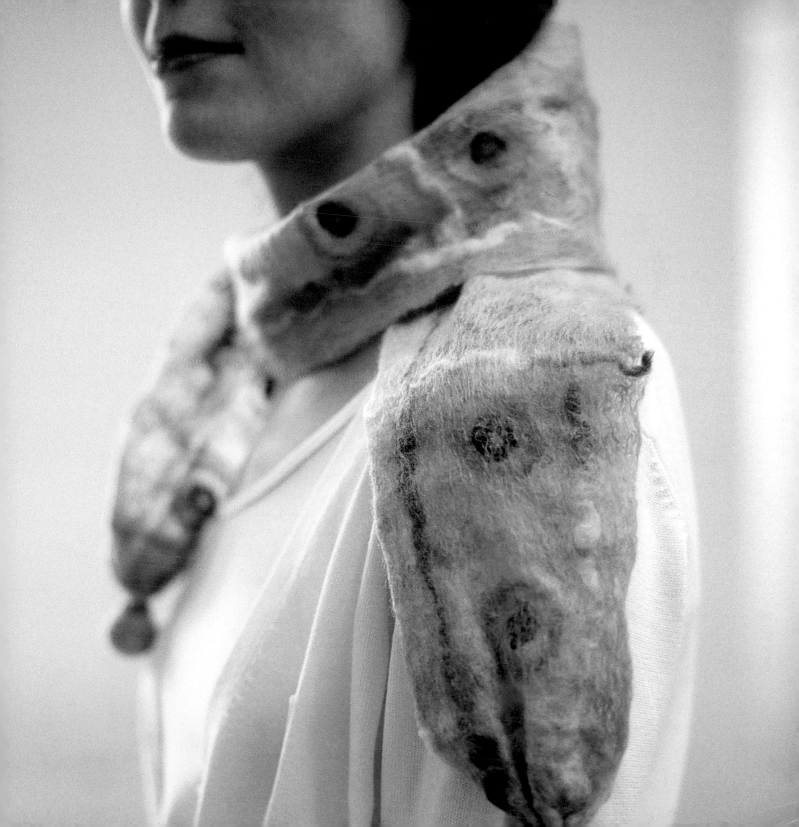

Materials

Merino wool tops:
 30g of pale blue, candy
 pink and lime green

 Small amounts of
 peach, peppermint
 green, red and
 turquoise

2 different colours of
heat-bondable Angelina
glitter fibre or similar

Small amount of One Zero
yarn by Colinette in
Popsicle, approx. 100m
(109yd) per 100g hank,
(100% wool)

Size
Approx. 16 x 196cm
(6½ x 78½in)

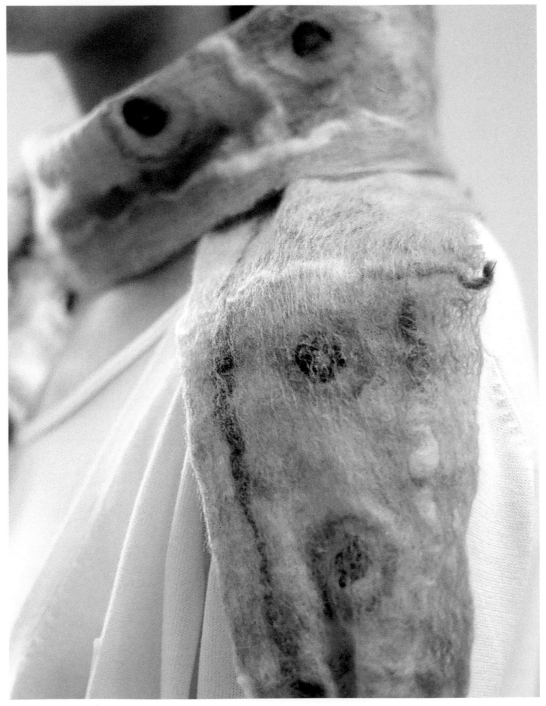

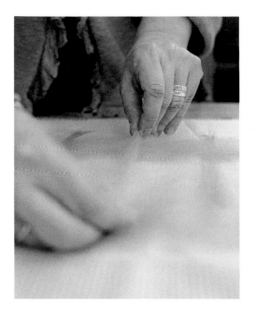

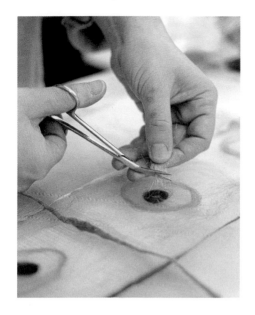

1 Laying out fleece

Working on netting over the bamboo mat, lay down very wispy layers of fleece to form the under layer of your scarf, keeping in mind that your scarf will shrink by approximately 20% during the felting process. Lay strips of pink, lime and pale blue fleece lengthwise, with a small vertical gap between each colour. Then lay alternate rows of peppermint green and peach fleece at 7.5cm (3in) intervals horizontally over the top.

2 How to design

Remember to use very little fleece to make your design and feel free to leave gaps where there is no fleece at all. Create coils with the turquoise fleece and place lengthwise down scarf at regular intervals. Create a smaller red coil and place inside the turquoise coil.

3 Trapping

Lay two lengths of yarn down the length of the scarf, 5cm (2in) in from each outer edge. Cut seven or eight pieces of yarn the width of the scarf and place them horizontally between the circles. Lay wisps of Angelina glitter fibre in a line down the inside of the two lengths of yarn. Using small scissors, cut snippets of a contrasting colour Angelina fibre into the red circles to add some sparkle.

 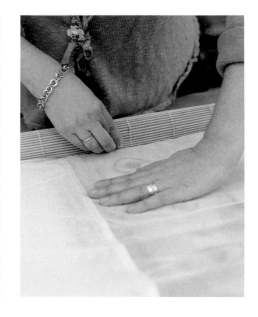

4 Overlay of fleece

Working back to front, place a little more wool fleece over the top of these yarn and glitter components to trap them in the scarf and keep them in place. Next repeat step 1 in reverse, by first laying peppermint green and peach horizontally. Then vertically lay one layer of pink fleece over the blue, lime over the lime and blue over the pink.

5 Wetting

Mist down the fleece using soapy water in a spray bottle. Because the project is so delicate, take care not to over wet. You do not need as much water as in previous projects. It just needs to be damp – it is the soap in the water that is important.

6 Rolling up bamboo

Lay another piece of netting over your scarf. Tightly roll the bamboo mat from one end, taking care to keep the fleece as flat and undisturbed as you can.

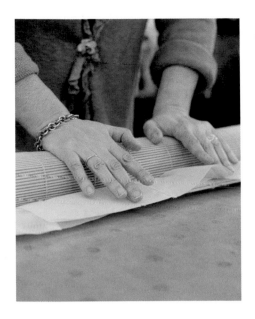

7 Rolling

Firmly roll the bamboo mat back and forth at least 500 times before opening it up to check for fibre movement. Fibres should be well matted together, and should not move when brushed against. If they do, continue rolling between 100 and 200 times more or until they are fixed. Rinse the scarf with boiling or very hot water, then allow to cool a little. Repeat the entire rolling process again, rotating the scarf through 90°C (195°F) occasionally to control shrinkage in both directions. Do a final rinse to make sure all the soap is removed and then a final roll. Allow to dry.

8 Finishing

Place a tea towel over the scarf, set your iron to the wool setting and press firmly to bond the fibres and flatten your scarf. Create two felt balls (see page 52) for the ends. Decorate the balls with some lime polka dots using the felting needle.

9 Attaching

Gather the end of scarf together and stitch a felt ball in place with a needle and thread. Repeat at the other end.

advanced
★★★

nuno felt shawl

"Nuno", the Japanese word for cloth or fabric, is a term coined to describe felting onto fabric. The advantages of this method are that a very fluid, lightweight felt fabric can be created, and interesting effects can be achieved as the shrinking wool causes open weave fabric to pucker and crinkle. Of all feltmaking techniques, this is the most popular one used to create clothing. As with the cobweb felt, don't overdo the amount of fleece you use – very little is required.

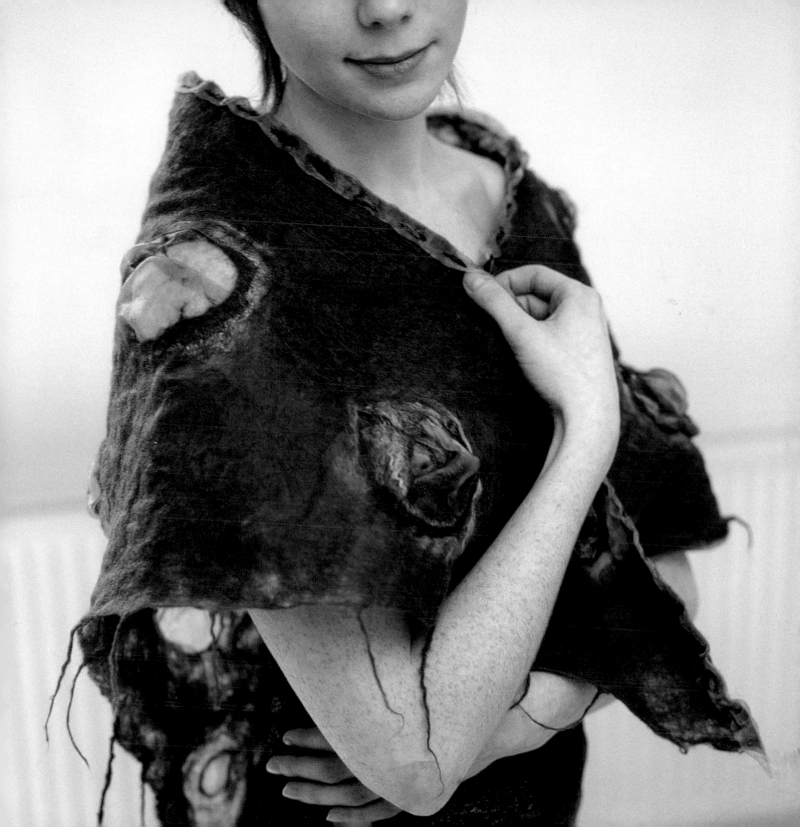

Materials

Merino wool tops:
 50g of purple

Small amounts of
 darker purple and olive
yellow

Small amount of silk tops
in space-dyed pink/yellow
tussah

I large triangle of organza
with each of the right
angle sides measuring
approximately 100cm
(40in)

Matching thread, braid or
ribbon

Size

Each right angle side
approx. 100cm (40in)

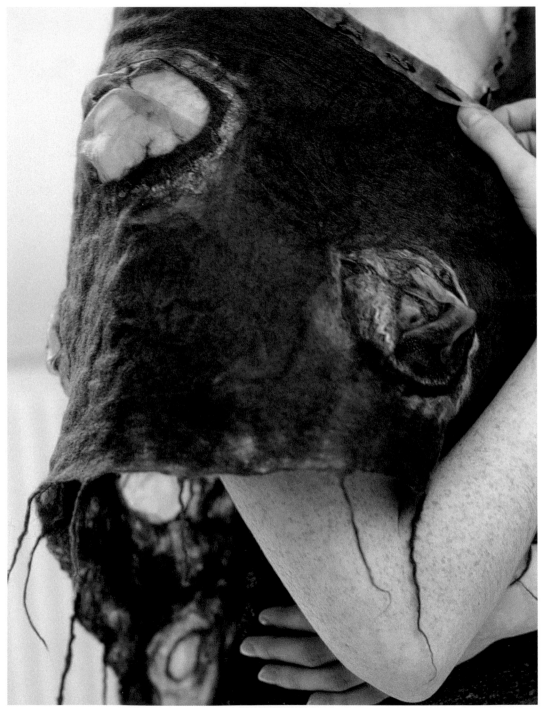

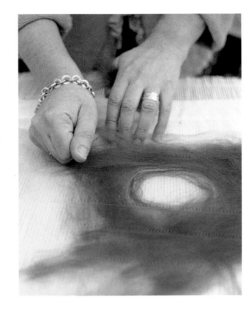

1 Fabric choices

Open weave fabrics such as chiffon, organza, gauze, voile, tulle or cheesecloth are best for nuno felting, as their open weave texture allows the wool fibres to travel through and take a good strong hold. As a rule of thumb, if you can see through it and feel your breath through it, the fabric will be fine to work onto.

As shrinkage occurs, the unfelted areas of fabric will be gathered in to create interesting textures. Finer and more delicate effects are achieved by using silks, but equally interesting outcomes are possible when using man-made fibres such as the polyester organza I've used here.

2 Trapping

Although it is fine to work directly onto the bamboo mat, I prefer to lay a piece of netting over the mat as it allows me to see the amounts and colours of the fleece being laid out much more clearly. Textural effects can be achieved by trapping in silk tops or other interesting yarns. Lay your organza down, then create the circle outlines by laying very fine amounts of dark purple and olive yellow fleece around in a circle and trap the pink/yellow silk within it.

3 Laying fleece

Lay small amounts of wispy purple fleece at the hem of the shawl to form the fringes. Then lay very small amounts around the circles so that the fleece just covers the fabric. Lay fleece along the edges, but leave a 5cm (2in) gap running along the top edge, in order to create a slight frill when the wool shrinks. As always, vary the direction the fleece is laid out in as much as possible.

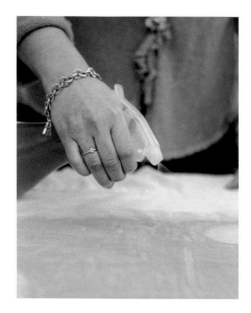

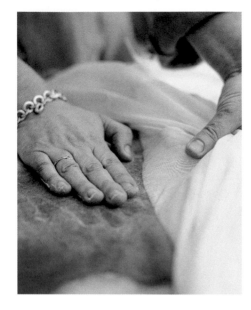

4 Wetting

Lay a piece of netting over the top when you have finished creating your design, taking care not to disturb the fibres. It's important to wet thoroughly now with a cool soapy water solution. The water should be cool because this felting process needs to be done slowly so the fibres will felt with the organza. Using hotter water might cause the fibres to felt to themselves before they have had a chance to travel through the fabric.

5 Rubbing

Use a cloth to mop up excess water. Rub a bar of soap over the piece and start to rub the fabric thoroughly. The rubbing process will take quite a while here, as you need to carry on until the wool fibres have travelled through to the back of your organza to hold the whole thing together.

6 Peel back netting

Periodically peel back the netting to prevent the fibres from trying to felt themselves to it instead of to the organza. Separate the fibres from the netting and keep on rubbing.

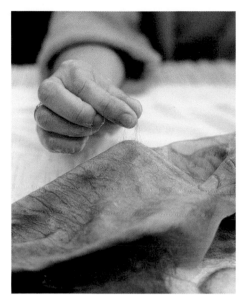

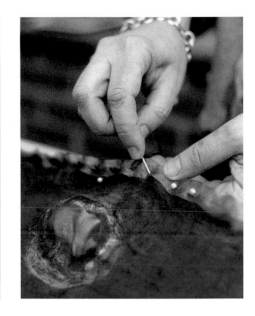

7 Set felt

Continue rubbing until the fleece has bonded to the organza underneath. Check by looking at the back of the fabric to see how many fibres have come through. Also rub your hands over the front to check if the fibres have thoroughly knitted to the background and no longer move around.

Once the fibres have clearly come through the fabric, rinse the project with warm water. Do a complete roll in the bamboo mat, rolling 30 times in each direction and on both sides, turning to control shrinkage. Rinse in hot water. The temperature of the water depends on the fragility of the fabric you are using – use boiling water if your fabric can withstand it. Repeat the entire rolling process until you achieve your desired result.

8 Shrinkage effect

Once the fibres have begun to shrink, the organza will pucker and distort as it is pulled by them. Do a final rinse in warm water to rinse out all soap.

9 Finishing

Finish the raw edge by folding over the top edge twice. Using a decorative ribbon or embroidery thread, sew a running stitch along the top.

advanced
★★★

blooming slippers

Feet first! Lounge around in these totally toasty slippers and your feet will feel so warm you can pretend you are on a desert island. The seamless slippers are made around polystyrene shoe lasts, which are available in most sizes. They are also lightweight and can be put in the washing machine at the final fulling stage.

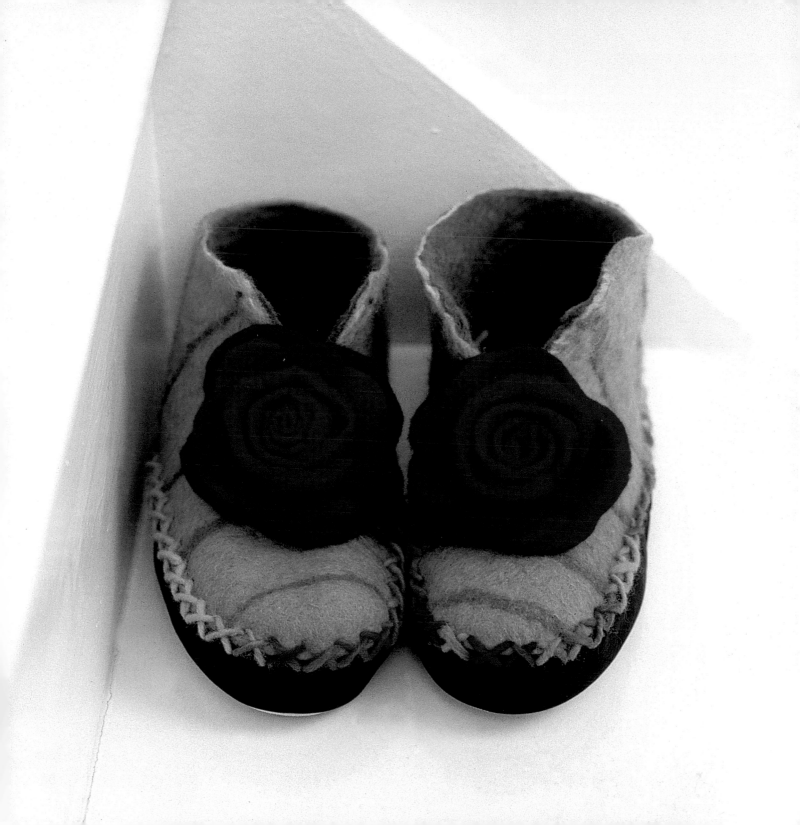

Materials

Merino wool tops:
 50g of turquoise, citrus,
 lime green, red and
 dark red

A pair of polystyrene shoe
forms in the appropriate
size

Fabric glue

Needle and thread

Slipper soles or piece of
suede (optional)

Size

Length 28cm (11½in)
Width 10cm (4in)
Height 11cm (4¼in)

1 Covering

The best results are achieved by using proper polystyrene forms for this project, but you could try working over rubber boots. To make it easier to remove your finished slippers from the lasts, start by covering each with a plastic bag and securing the bag with an elastic band at the top. Now mist the plastic bags with soapy water – this will help keep the fleece in place as you are laying it on top.

When making slippers, you need a minimum of three layers to make them thick enough. It's helpful to make these three layers in different colours so you can see when you have layered sufficient fleece for each.

2 Laying fleece on last

Start by laying turquoise fleece onto the last. Work as described on page 22, pulling off wispy amounts of fleece and layering it up slowly. Do not be tempted to wrap large bandage-like swathes of fleece around the last, as this will not work!

First lay the turquoise fleece along the sole of the last, overlapping at either end. Then wrap wispy fleece crossways over the top in the opposite direction. Cover with a small piece of netting, wet, soap and rub for a few minutes. Next, lay the last on one side and cover the first side with wispy fleece from left to right, and then in the other direction from top to bottom. Cover, wet, soap and rub again before doing the other side. Repeat with a citrus fleece layer and then a lime fleece layer, then repeat everything again for the other foot.

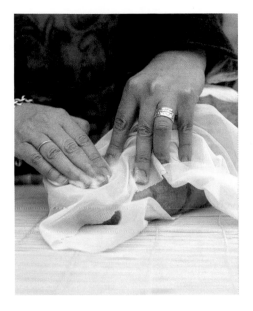

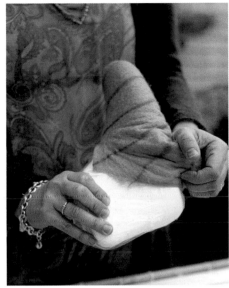

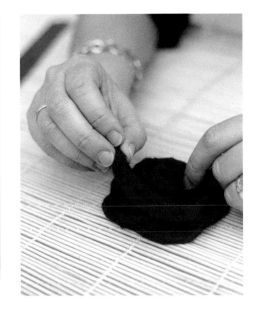

3 Rubbing

Lay turquoise decorative stripes across the slippers. Cover, wet, soap and rub until the fibres no longer move when you brush your hand across them. This is important!

Next, put the slippers in washing machine on a 60°C (140°F) wash cycle. Add an old pair of jeans to the wash to facilitate the felting process.

4 Remove lasts

Using a small pair of scissors, cut 2.5 5cm (1-2in) down from the top centre to aid the removal of the lasts from the felt. If the slipper is damp, it will be easier to remove the last. However, it's beneficial to dry the slippers on the last to maintain a good shape. If necessary trim the top of the slippers to make them even and matching.

5 Making flowers

Start by making 25cm (10in) squares of basic flat felt (see page 22) in red and dark red. Cut a freeform flower shape 9cm (3½in) in diameter in dark red, then a 7.5cm (3in) wide four-petal flower in each colour. Cut an uneven 30cm (12in) length in red to coil in the centre. Place the four-petal flowers on top of the petal base alternating colours and the coil on top. Glue if necessary, then stitch in place.

Attaching the Soles

Pin the sole to the bottom of the slipper. Using colourful yarn or embroidery thread, sew the sole on using a decorative stitch such as cross stitch. Sew the flower into place in the centre after you have finished. As an alternative, cut two pieces of suede slightly smaller than the sole of the slippers. Tack into place with some adhesive, then oversew with some strong thread.

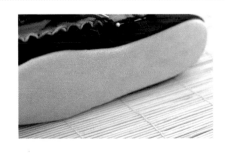

advanced
★★★

bowl over ball

You'll have a ball making this project! Layers of fleece are built up around a ball, and then a second shape – in this case, a small plastic bag with a core of aluminum foil – is placed onto the side of the ball and the felting continues over the top. This small appendage will eventually become the flower on the side of the bowl, once both shapes have been cut open.

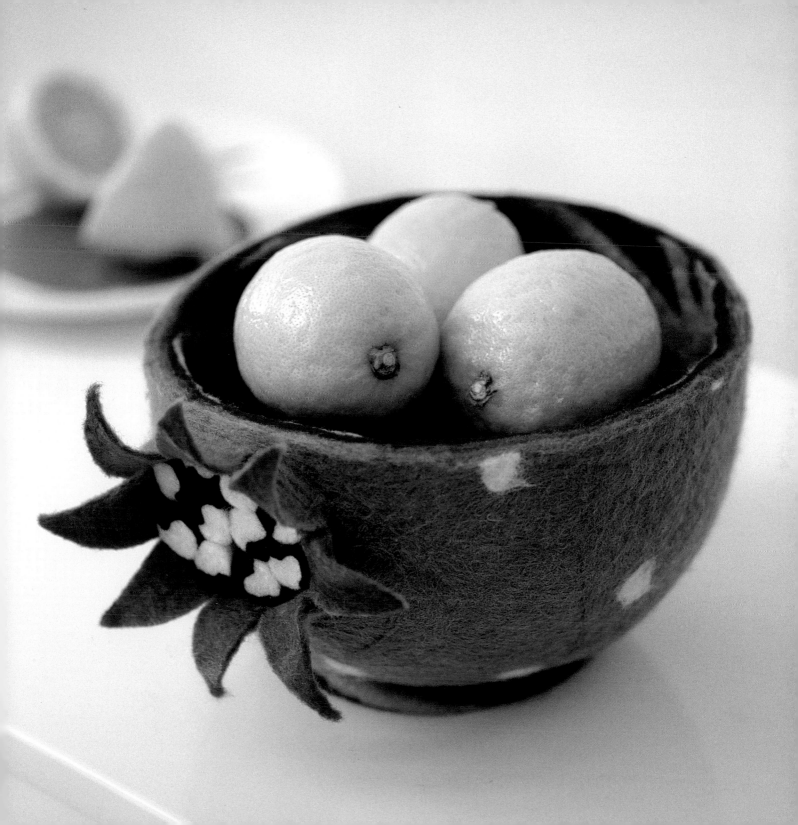

Materials

Merino wool tops:
 50g of candy pink, cherry red, cornflower blue, olive green and coral

 20g of white and black

 Small amounts of orange and rust

20cm (8in) plastic ball

Some aluminum foil

A small plastic bag

Fabric glue

Needle and thread

Size
Height 14cm (5½in)
Width 26cm (10½in)

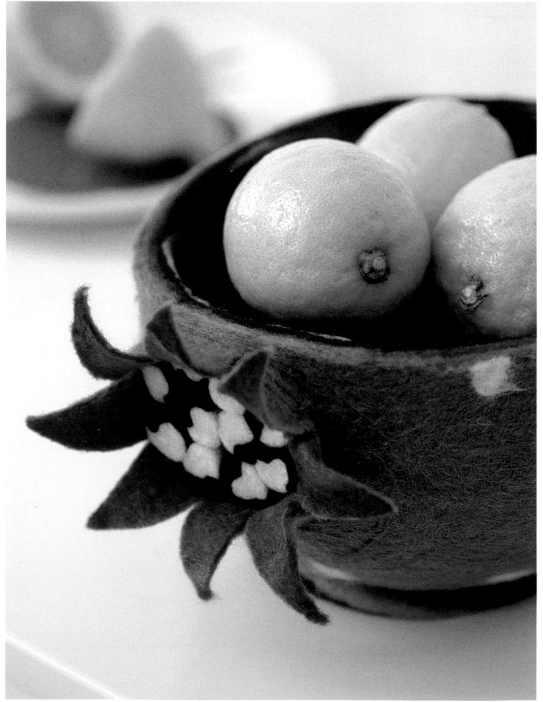

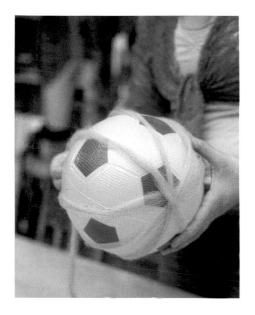

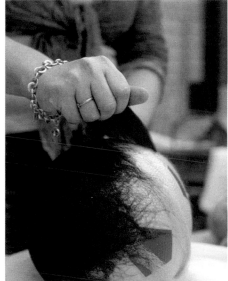

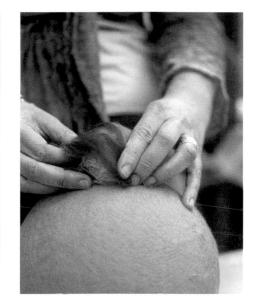

1 Inside design

First of all, spray the ball with some soapy water, as this will make life easier and help the fleece stay put. Take long strips of candy pink fleece and wrap it around the ball (see photo above). Join the strips together as you go to make the pattern appear continuous.

2 Covering in fleece

Working on a third at a time, start to cover the entire ball in red fleece, laying it in alternating directions. After working on one section, place the netting over the laid fleece, spray it with soapy water, add soap and rub for a few minutes. Occasionally pull the netting back to separate the fleece from it. Keep adding fleece until the entire ball is covered, repeat this with coral fleece then with olive.

3 Appendage

Create a small ball out of aluminium foil, then wrap a small plastic bag around it. Cover one side of this plastic bag ball in a few layers of orange and rust fleece for the petals. Trim off excess where necessary. Place the small ball onto the side of the main ball and start to cover it with the olive green fleece. Make sure you add enough olive fleece over the top to keep the smaller ball in place – keep adding fleece in different directions over it. Now apply the cornflower blue fleece layer, working around the small side ball this time. Add your white polkadots, remembering to keep the dots fairly loose! Rub everything until the fleece no longer moves when you run your hand over it.

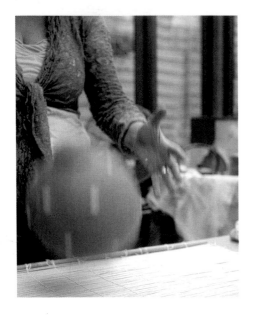

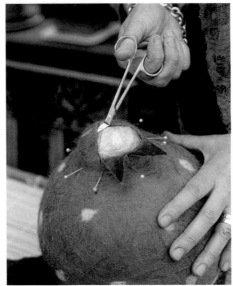

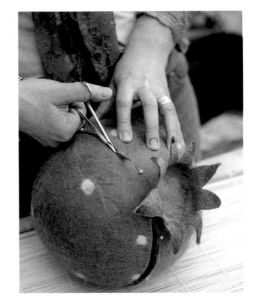

4 Bouncing

Now this part is just for fun, although the vibration of the bouncing ball will help to entangle the fibres, so do it for a few minutes if you can! Either bounce or rub – or a combination of the two – until the fibres feel completely 'together' and you are confident your ball of fleece definitely won't fall apart. Then it is time to put it into the washing machine, put your feet up and relax. If possible, add an old pair of jeans or some old sheets or blankets (not towels) to the washing machine to add friction and then wash at about 60°C (140°F) with your normal washing powder.

5 Cutting open flower

While everything is still damp, mark seven to eight petals in the small side ball with some pins. Cut the petals from the centre outward towards each pin. Bend the petals back into the shape you want them to dry in. Now leave to dry before you cut open the main bowl.

6 Cutting open bowl

Mark your cutting line on the main bowl with pins or a piece of string. Ideally, your flower should sit just below the top of the bowl, so the petals protrude over the top. Cut around the ball on the cutting line and then remove it. Trim and tidy the edges as necessary.

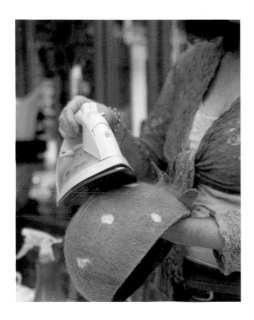 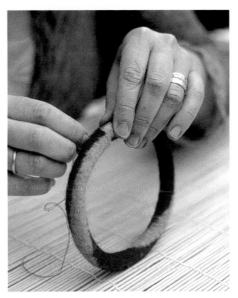 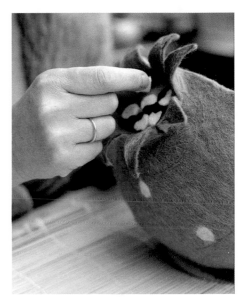

7 Stiffen and smooth

Spray starch liberally over the ball to stiffen. Set the iron to the wool setting and, without steam, carefully press the outside of the bowl, taking care not to burn yourself. If you find it easier and safer, place the felt bowl over another glass bowl before you begin to press.

8 Felt bowl stand

For your new felt bowl to remain upright (especially once you put things in it) you need to make a felt stand for it to sit on. This is easily done with a coiled length of felt. Make a felt handle (see page 53) by twisting 40cm (16in) pieces of red and candy pink fleece together. Once fulled, wait for the felt to dry, cut it to the correct length for your bowl, then form a circle by joining the two clean ends together. Glue them to hold, then sew to secure.

9 Decorating

Create another twisted length in the same way, but this time using black and white fleece. Allow to dry, then cut it into 6mm (1/4in) slices. Glue some of these into the centre of the flower.

advanced
★★★

field of poppies

Although this project incorporates many techniques,
it focuses on using the fleece with a more painterly
approach than before. By treating the fleece wool tops
like paint and applying it in very thin layers, tonal
watercolour effects can be created. There is also
a 'pre' felt – or 'half' felt – inlay in the wall hanging,
which is a useful technique to learn as it caters to
those who like a circle to remain perfectly round!

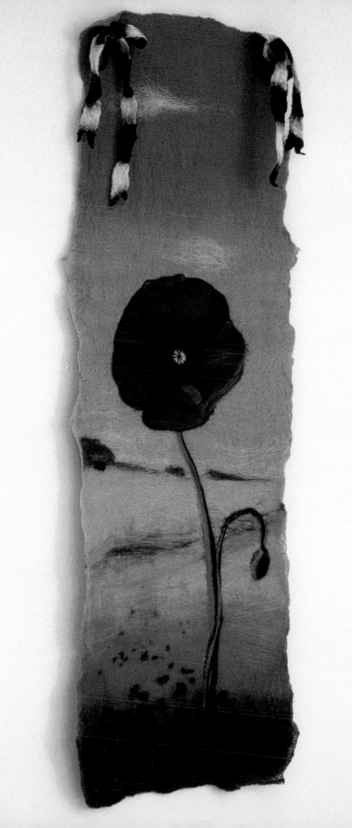

Materials

Merino wool tops:
 100g of pale pink

 50g of cornflower blue,
 light blue, pale blue,
 dark green, sage green,
 pale lime, dark red and
 bright red

 30g of black and white

 Small amounts of coral,
 peach, burgundy, dark
 blue, grass green,
 white, purple, black,
 olive green and lime
 yellow

Hook-and-loop tape

Size

115 x 38cm (46 x 15in)

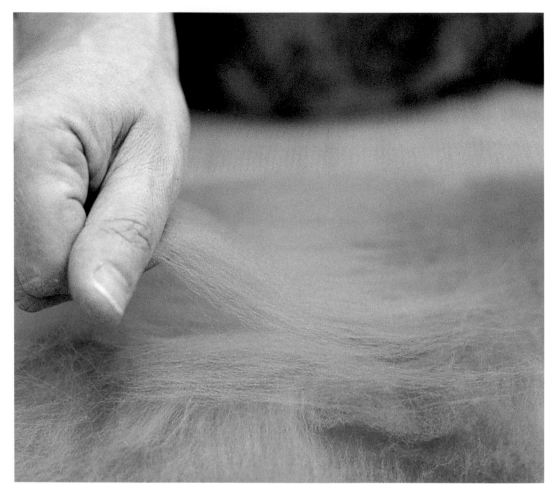

1 Laying fleece

First lay pale pink fleece lengthwise to form a rectangle about 135 x 42.5cm (54 x 17in), or the size you require plus 20-30% to allow for shrinkage. Remember, it is easier to trim the felt down at the end, than to add on if it shrinks too much! Follow the first layer with another of pink going horizontally. To create the sky, gather together lengths of three or four different blues to blend together. Lay a fine layer of each in descending order, with the lightest at the bottom. Next, lay the same blues horizontally and start overlapping them. Continue to cross hatch with fleece where each blue changes into another, until the blending appears seamless. Lay the greens out for the grass in a similar manner, although having more defined areas of different coloured greens is fine here, as you would with different fields. Lay a band of wispy red fleece across the top of the grassland to imply some out of focus poppies in the distance.

2 Pre-felt

Pre-felt inlay is a common way of creating and adding shapes and patterns into felt, which will retain their form and move around less when put through the felting process. This technique requires some simple flat felt pieces to be made in advance in the colours required (in this case reds) but stops before the pieces are totally fulled. If they are already felted and have shrunk too much, it will be more difficult to get them to adhere to your new creation.

First make the flat felt (see page 22), but stop after the first rolling in the mat and cut the shapes you require – in this case, oval shapes to indicate the poppies in the foreground. Lay shapes into the new fleece.

3 Layout poppy

If possible, use a colour photo for reference. Lay down the bare bones of the flower using different reds, and the stem using different greens. Layer small amounts of different tones on top of each other to create light and dark areas and to add contrast.

Now start the felting process as described on pages 22-25. Once you have finished, leave the felt wall hanging to dry before continuing further.

4 Adding needle felt

Now you can really start to add the fleece in very small amounts, building up layers of tone and colour as you would with paint.

Take wisps of black fleece and create the tiny centres of the poppy at the bottom of the wall hanging, using a felting needle. Also needle felt a few stems with some dark green. Next, start to create your horizon using small amounts of greens and brown. Out of focus shapes will look like trees when you step back and look. Begin to think about grassland and lay extremely wispy strands of fleece across horizontally. Fix in place with the multi-needle tool. Keep stepping back from your work and then adding fine layers of fleece in areas which need to be built up with colour.

5 Poppy design

Really spend some time on the flower, as it will stand out from the rest of the wall hanging. Referring to a photo or drawing, build up the petals using as many different shades of the same colour as you can. Here I have used different reds, burgundy, peach and coral fleece just for the petals. Look at the poppy centre and add black and white fleece and some purple stamens.

6 Finishing: adding ties

If you're planning to make this project into a blind rather than a wall hanging, make a flat piece of black and white striped felt to create two long straps to use as ties. Attach a piece of hook-and-loop tape at the top back of the blind, and fix to the wall or window. Sew a tie on either side at the top. During the day when the blind is rolled up, use the ties to hold it in place.

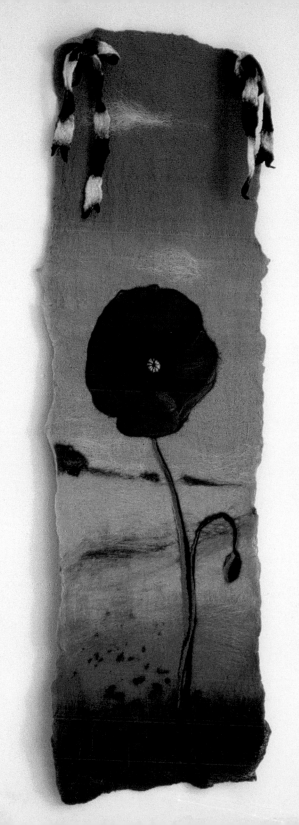

Candid Camera

Your work will really benefit from having photographs or preliminary sketches to work from. For example, use photos of the countryside as a reference to see how colours change and alter in the distance. Half close your eyes when you look at a photograph, and try and look at it out of focus. By doing this you will able to see which colours of fleece will be right for the effect you are after.

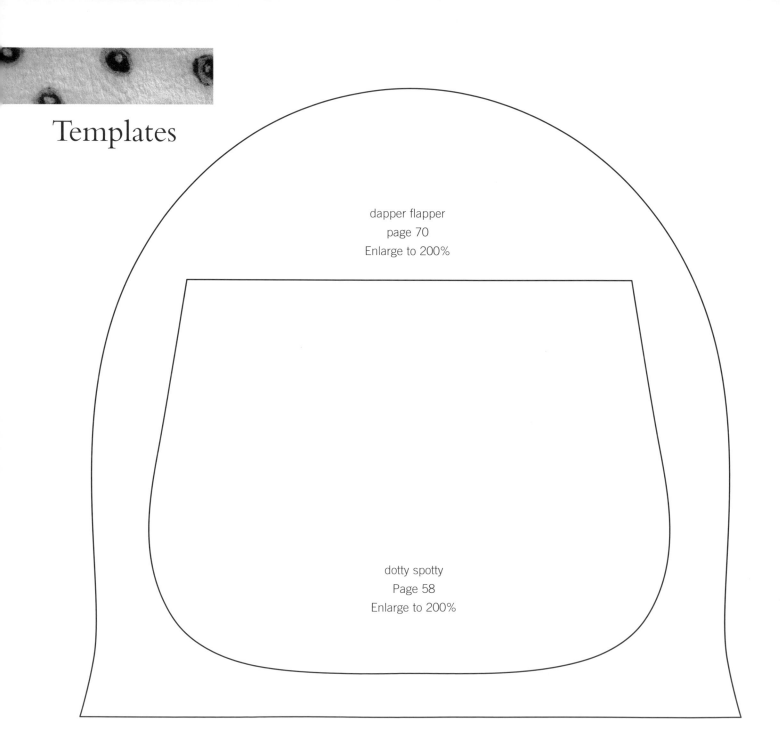

Templates

dapper flapper
page 70
Enlarge to 200%

dotty spotty
Page 58
Enlarge to 200%

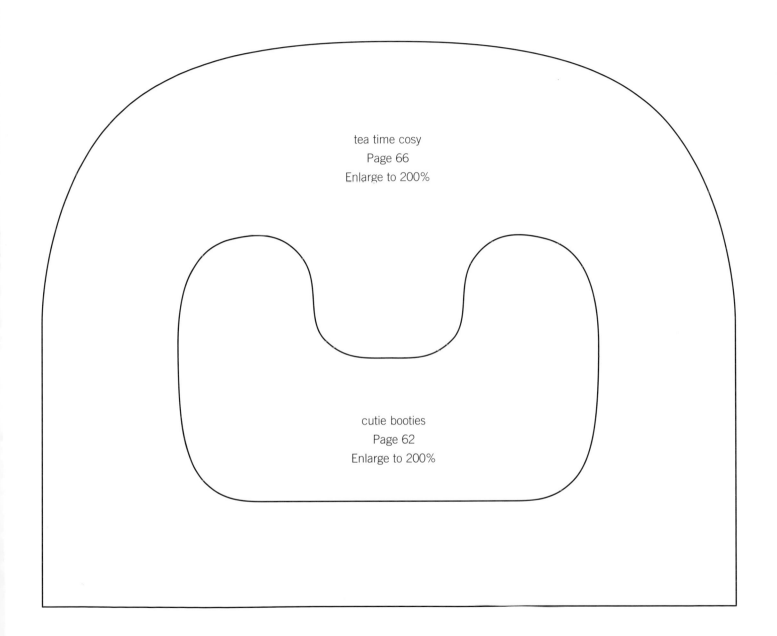

tea time cosy
Page 66
Enlarge to 200%

cutie booties
Page 62
Enlarge to 200%

Glossary

Angelina fibre: A very fine, glittery and light reflective fibre that is sometimes heat bondable. Comes in three types: iridescent, holographic and metallized.

Batt: A carded mass of fleece that can be separated into layers. Used as an alternative to wool tops. Unlike wool tops, the fibres do not all face in the same direction. Often used in large expanses with felting needles to form flat sheets of needle felt.

Block: A block is a form used in making and drying a piece to a desired shape. Hat blocks are often used when making felt hats.

Blood count: An American method of grading wool, based on the percentage of Merino breed in the original sheep.

Boiled wool: Traditionally this is knitted wool that has been boiled in order to obscure the knitted stitches. Done in a controlled environment to produce an even cloth from very fine wool. Many wools will distort and lose their colour at such a high temperature.

Bradford count: A British wool grading system, which refers to the number of 560-yard skeins of wool from a pound weight. The higher the count, the finer the wool.

Carding: A process very similar hair brushing. Using either metal-pronged hand carders or a drum carder, the wool fibres are combed out into long, even lengths, so that all the fibres are facing in the same direction.

Crimp: The waviness of the wool fibres. Finer wools have much more crimp per inch than coarser wools.

Felting: The matting together of wool fibres to form a dense fabric that is stable and does not fray.

Fulling: The final stage of shrinking and hardening the felt or knitted fabric to make it thicker and denser.

Felting needles: The barbed needle that is repeatedly poked in and out of wool tops to produce flat or sculptural pieces of felt without the need for water. The barbs on the needle entangle the wool fibres as they are pulled in and out. Different gauge needles have different effects on the wool.

Fleece: The wool from a sheep in one piece, containing lanolin. Also a term I use to refer to wool tops being used for feltmaking.

Gauge: Refers to the size of a felting needle. The higher the gauge, the more delicate the needle. Fine needles are suited to a finer decorative application of fleece. The lower gauge needles are used for forming basic shapes and sculpting. The needles also come in different shapes; triangular and the multi-faceted star shape, which is faster to work with. Finer needles break more easily. In knitting, it refers to the number of knitted stitches and rows in a defined square.

Handle: The feel of a fibre or fabric.

Lanolin: The grease or wax produced by the sebaceous glands of the sheep. It has waterproofing qualities, and prevents the sheep from becoming too wet. Although most is removed during scouring, what little remains has the added benefit of preventing sore chapped hands after many hours of feltmaking. Lanolin is used by the pharmaceutical industry.

Lasts: Forms over which shoes or boots are made.

Micron: A micron is a millionth of a metre (or 1/25,000 of an inch) and is the most accurate way of grading wool. The lower the micron, the finer the wool.

Nuno felt: Felt that incorporates a fine fabric. It is most suitable for felt clothing, as the results maintain their draping qualities. Comes from the Japanese word "nuno" meaning fabric.

Pre-felt: Half-made felt that is then inlaid into further projects on top of new wool tops, to create uniform designs that don't move around too much.

Roving: Similar to tops, but the fibres do not always face the same direction.

Scales: The tiny overlapping scales on the surface of the wool fibres, which open up from the base to the top and then lock together once they have entangled during felting. Hot water encourages the scales to open up and cold water to close again.

Scouring: The act of washing the wool when it is first shorn to remove dirt, grease and bits of vegetation!

Silk noil: A by-product of silk – wonderful for creating textures trapped in wool.

Staple length: The fibre length of wool, which varies according to the sheep.

Stocking stitch (St st): A knitting term referring to altering rows of knit and purl.

Tops: Wool tops refers to the continuous length of wool fibres produced during the carding process, in which all the fibres lie in the same direction – making them ideal for layering in feltmaking. They are sold in different lengths, and are usually between 2.5-7.5 cm (2-3 in.) wide.

Washboard: Used as an alternative to a bamboo mat in the feltmaking process, as part of the fulling technique. The felt is rubbed against it vigorously instead of being rolled in a bamboo mat.

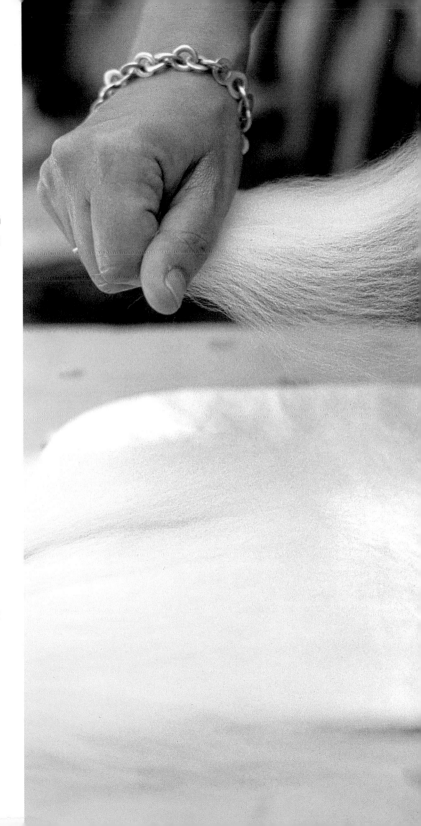

Resources

Felt Kits & Felt Courses

For starter kits, slipper kits, wool tops, and Felt Making Courses in the UK:

Gillian Harris
www.gilliangladrag.co.uk

Wool Tops, Silk Tops, Other Fibres, Felting Needles, Angelina Fibre

Crafty Notions
Unit 2, Jessop Way,
Newark, NG24 2ER
Tel: 01636 700862
www.craftynotions.com

Wingham Wool Work
70 Main St, Wentworth
Rotherham, South Yorkshire,
S62 7TN
Tel: 01226 742926
www.winghamwoolwork.co.uk

George Weil Fibrecrafts
Old Portsmouth Road,
Peasmarsh, Guildford,
Surrey, GU3 1LZ
Tel: 01483 565800
www.fibrecrafts.com

The Handweavers Studio
29, Haroldstone Road
London, E17 7AN
Tel: 0208 521 2281
www.geocities.com/Athens/
Agora/9814/index.htm

Texere Yarns
College Mill, Barkerend Road
Bradford, BD1 4AU
Tel: 01274 722191
www.texere.co.uk

Hilltop
Windmill Cross,
Canterbury Road, Lyminge,
Folkestone, Kent, CT18 8HD
Tel: 01303 862617
www.handspin.co.uk

Twist Fibre Craft Studio
88 High Street, Newburgh
Cupar, Fife, KY14 6AQ
Tel: 01337 842843
www.twistfibrecraft.co.uk

Knitting Wools

Colinette Yarns
Banwy Workshops,
Llanfair Caereinion,
Powy, Wales, SY21 0SG
Tel: 01938 810128
www.colinette.co.uk

Rowan
Green Lane Mill
Holmfirth, HD9 2DX
Tel: 01484 681881
www.knitrowan.com

Noro Yarn
Designer Yarns Ltd
Unit 8-10, Newbridge Industrial
Estate, Pitt Street,
Keighley, West Yorkshire
BD21 4PQ
Tel: 01535 664222
www.desyarns.co.uk

South West Trading Company
www.soysilk.com

The Knitting Parlour
4a Graham Road
Great Malvern, Worcs,
WR14 2HN
Tel: 01684 892079
www.theknittingparlour.co.uk

Hand Spun / Hand Dyed Yarns:

www.materialwhirled.com
www.pluckyfluff.com
www.jennyneutronstar.com

Space-Dyed Textiles

Kate's Kloths
58, Regent Street
Blyth, Northumberland
NE24 1LT
Tel: 01670 354342
www.kateskloths.co.uk

DYES

Omega Dyes
Tippets Cottage,
Kenwyn Church Road,
Truro, Cornwall,
TR1 3DR
Tel: 01872 227 323
www.omegadyes.fsnet.co.uk

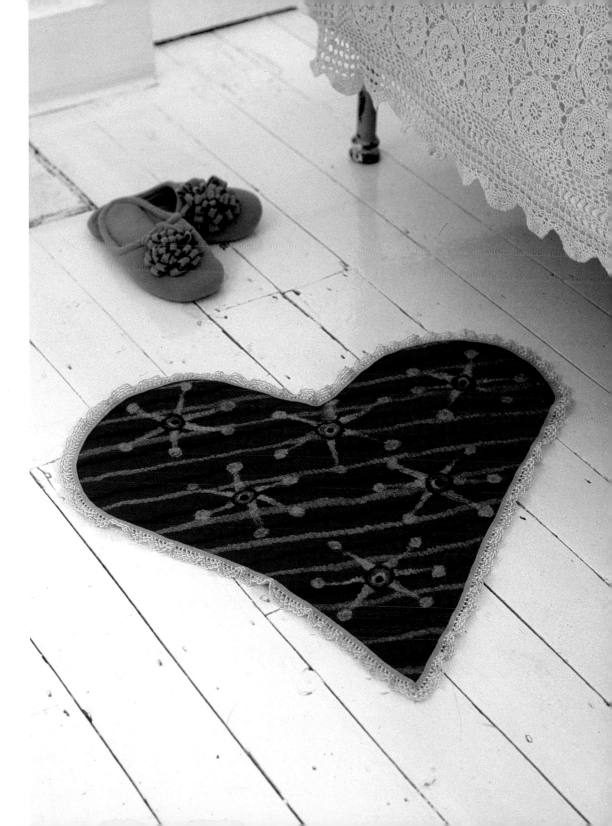

Trimmings & Ribbons

Regia Soles for Slippers

VV Rouleaux
54 Sloane Square
Cliveden Place
London
SW1W 8AW
Tel: 0207 730 3125
www.vvrouleaux.com

Further reading and
information on feltmaking:
**International Feltmakers
Association**
www.feltmakers.com

Acknowledgements

This book is dedicated to my wonderful friend, the late Alix Morze, who first suggested I should felt, and was the most unique, inspiring and encouraging person I have ever met.

I'd also like to thank my husband, Chris, and my two daughters, Polly and Rosie. for being so patient with me. Sorry if you found bits of fluff in your dinner. And sorry if you didn't get any dinner.

I'd like to extend my gratitude to Maureen Saunders for knitting up the corsage, bag, and baby blanket and Reenie Hanlin from www.materialwhirled.com for donating yarn for the Carousel cushion. In addition, Michelle Lo and Mark Winwood for being so lovely to work with. Lastly, to Mum and Dad for their constant support and for passing down the fluffy textile gene.